IMAGES
of America

CENTEREACH, SELDEN, AND LAKE GROVE

IMAGES
of America

CENTEREACH, SELDEN, AND LAKE GROVE

The Middle Country Public Library

ARCADIA
PUBLISHING

Copyright © 2015 by the Middle Country Public Library
ISBN 978-1-4671-2297-9

Published by Arcadia Publishing
Charleston, South Carolina

Printed in the United States of America

Library of Congress Control Number: 2014947949

For all general information, please contact Arcadia Publishing:
Telephone 843-853-2070
Fax 843-853-0044
E-mail sales@arcadiapublishing.com
For customer service and orders:
Toll-Free 1-888-313-2665

Visit us on the Internet at www.arcadiapublishing.com

CONTENTS

ACKNOWLEDGMENTS

The Middle Country Public Library gratefully acknowledges those who made this book possible. Barbara Russell, Brookhaven town historian, graciously shared her resources, time, and knowledge. Kristen J. Nyitray, head of special collections and Stony Brook University archivist, provided us with atlas and archival materials. Joyce Bogin, church historian for the First Congregational Church of New Village and her father, Sidney Williams, shared their photographs and memories. Cathy Ball, supervising librarian of the Smithtown Library's Long Island Room, enthusiastically shared her knowledge and collections.

Ray Welch, retired Suffolk County Community College biology professor, documented the history of the tuberculosis sanitarium and early college days. Virginia Amaro Tanner, longtime Selden resident, educator, and historian, volunteered community information, including photographs and memorabilia. Ed Cortez, artist, lecturer, and historical ship model maker, kindly volunteered his beautifully rendered drawing of a Revolutionary-era whaleboat. Lake Grove Post Office staff shared photographs and ledgers of past years. Margaret Vitale granted access to the wooden structure that once housed the Lake Grove Post Office. Maria Blaut and the Lake Grove Beautification and Historical Society also supplied images. Thanks go to Carmela Constant, village clerk, for facilitating this connection to the beautification society.

Jim Mones donated his 1940 *Selden Street Directory* and provided many family photographs. Dennis B. Carman shared Selden Fire Department photographs. Centereach Fire Department staff members also contributed information. Gina Piastuck of East Hampton Public Library's Long Island Collection provided images of Capt. Daniel Roe's original handwritten diary. Good Steer management kindly shared history and images of their restaurant. Many, many community members came forward to generously share their stories, historical documents, and photographs. Thanks also go to the staff of the Middle Country Public Library for their assistance in creating this work, especially our research and writing team: Theresa Arroyo, Sara Fade, Ryan Gessner, Carol Gray, Dennis Moran, Jim Ward, and Luise Weiss, and our director, Sophia Serlis-McPhillips, for her passion for this project and continuous encouragement. Unless otherwise noted, all images appear courtesy of the MCPL Heritage Collection.

INTRODUCTION

Early in the 1700s, when Long Island was still covered with timber, a road, known as the King's Highway, was laid down the middle of the island. Often, it was covered with sand, mud, and snow, depending on the season, and travel was difficult, if not hazardous. Still, it did afford a pathway for carts and wagons and an occasional mail coach. A stretch of land in the center of the island, which began at the Smithtown border and ran to a place now called Paul's Path, in Coram, is the subject of this work.

Most of the homes and farms that were built in the early years of settlement are gone, and the hardy pioneers who built them are but figures in historical accounts. The names of a few, however, are memorialized in the roads we travel every day in our communities: Hawkins and Hammond, Smith and Howell, Hallock and Gould.

In this history, we have tried to re-create, through genealogies and reminiscences, census records and early newspapers, the lineage of both the homes and the families who occupied them. The communities of Selden, Centereach, and Lake Grove in those early days from 1750 on, were, by necessity, self-sufficient. As the *Diary of Captain Daniel Roe* attests, their days were guided by the weather for the planting and harvesting of crops to sustain them, the tides for shipment of cordwood for income, and the necessity of shelter for their cart horses and the sheep who provided wool for clothing and warm blankets.

For many, at the center of their lives, both spiritual and social, was the church. In 1818, the First Congregational Church was built in New Village. Sundays found the parishioners there in the morning and again in the afternoon in a building affectionately termed "the Lord's Barn." Almost a century and a half later, in 1960, the descendants of those founders built a new church around the corner from the first. The 1818 church became a National Landmark.

The coming of the railroad in the mid-19th century brought changes to these small communities. Crops could be shipped for sale in city markets. Urban dwellers could escape the summer heat of the city and find respite in country boardinghouses. And local residents who might never had traveled farther than a few miles from home could see the city sights.

With the onset of the Civil War, over a dozen men left the community to fight for the Union cause. Selden resident Samuel Dare enlisted at the age of 16 as a member of the New York Zouaves regiment. Mustered out at Fort Sumter, South Carolina, at the close of the war, Dare returned to the family farm. Always a strong civic leader, his annual prizewinning melons earned him the unofficial title of "Watermelon King."

The settlements grew slowly. In 1885, a Long Island gazetteer described the communities. Lake Grove had the largest population with 398. While consisting mainly of farmers, the "great and refreshing atmosphere" had caused several city men to establish country homes for themselves in this village. New Village, formerly called West Middle Island, was characterized as an old settlement of farmers with a population of 200, and Selden, a village of only 88 inhabitants, produced large quantities of melons and early garden vegetables.

As the 19th century waned, a bicycle craze gripped the nation. Wheelmen from around the island worked to complete the 15-mile Cross-Island Bicycle Path that ran from Port Jefferson through Selden to Patchogue. Selden resident Albert Norton's Wheelmen's Rest welcomed bicyclists from all over the island, neighboring states, and even the British Isles.

When New Village wanted its own post office, it was found there was another New Village in New York. Our New Village would have to select another name. New Village residents Francis Craft, Arthur Murray, and Frederick and Everett Emery met to choose a name. Centereach was chosen, as the hamlet was located in the center of the island from all four compass points. The first Centereach Post Office opened its doors in 1916, with Everett Emery as the first postmaster.

In the early 1930s, O.L. Schwenke bought a large tract of land in Selden and began to advertise lots for sale. Crowds of prospective buyers, sometimes 10 busloads at a time, would arrive on Sunday at the Nature's Gardens sales office, each hoping to find a "garden plot, a camp site or a vacation retreat" to call his own. There was no electricity, and water was gathered from street-corner pumps. Over time, however, summer homes became year-long residences, and neighbors banded together for better utilities, better roads, and better schools.

Centereach was the next to grow. In 1952, the Kaplan firm began to build homes in a development it called Dawn Estates. The Krinsky Organization quickly followed with plans for 1,500 homes to be built on 400 acres in a project called Eastwood Village. From 1940 to 1960, the population of Centereach alone grew from 628 residents to 6,700. In 1967, state senator Leon Giuffreda described the area in these words: "If a man today travels to the fastest growing county in the United States, to the fastest growing township, to the largest community located therein, he finds himself standing on a corner in Centereach."

For most of their history, the communities have been separate entities. In the early days of the one-room schoolhouse and even their successors, there were no high schools for either Centereach or Selden students. Centereach elementary school graduates attended Smithtown High School and Selden graduates went to Port Jefferson. In 1957, the two school districts merged and formed the Middle Country Central School District. While there are still two high schools, Centereach and Newfield, there is one board of education, with members from both former districts governing all 14 schools. In 2005, the Greater Middle Country Chamber of Commerce was formed to foster business growth in Centereach, Selden, Lake Grove, and surrounding areas. The Times of Middle Country masthead proclaims its audience as Centereach, Selden, and northern Lake Grove. The Middle Country Public Library, while operating out of two buildings—one in Centereach and one in Selden—serves all the residents of our communities.

The mission of the Middle Country Public Library's Heritage Collection is to collect and preserve the history of the area and to make it available to the public. We invite you to step back with us—to a time when the speediest land transport was a fast team of horses, when a month-old newspaper was the only source of news, and when, in the evening, as dusk turned to darkness, the only light was candlelight.

—Luise Weiss

One

EARLY SETTLEMENT
MID-1700s–1850

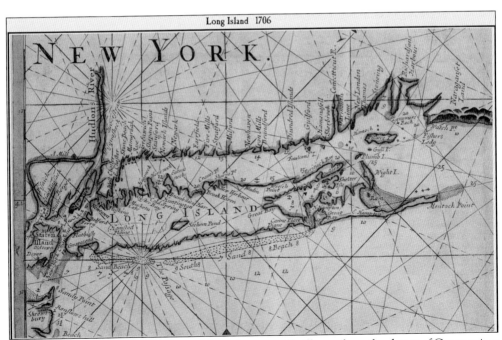

Long Island 1706

This rare 1706 mariner's map of Long Island shows small villages along the shores of Connecticut and Long Island, but the island's interior remains undeveloped. And so it was in the area now called Centereach, Selden, and Lake Grove. Around 1750, settlers arrived and the wilderness covered with trees made way for scattered small farms and roads, and so the story begins.

Located on the south side of Middle Country Road and the east side of Hawkins Avenue, this was believed to be the first house built in the west central part of Brookhaven Town, and records show that it was already lived in by Isaac Smith when the land was deeded to him in 1754 by his father, John Smith. It is here that Isaac and his wife, Jemina Platt, raised their 11 children, several of whom died in infancy. The house was destroyed by fire on January 1, 1962.

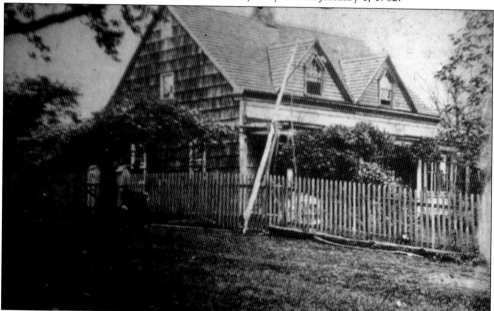

Located in New Village on the northwest corner of Middle Country Road and Hawkton Place, the land was farmed by three generations of the Hawkins family. Built around 1781, it was first occupied by William Hawkins (1760–1804) and his wife, Elizabeth Newton. Their eldest son, George (1784–1855), and his wife, Sarah Bayles (1790–1859), are listed as the next inhabitants, followed by their son John (1824–1910) and his wife, Angeline Newton (1833–1911), who both lived into the 20th century.

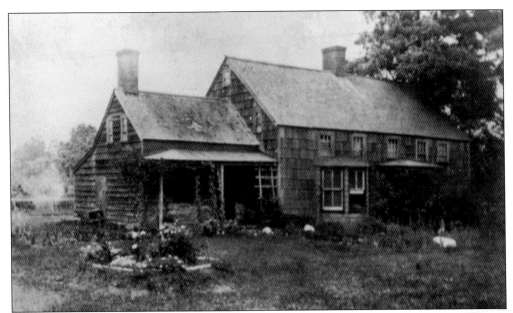

In 1790, Isaac Hammond (1763–1844) of Coram purchased 400 acres of land on the north side of Middle Country Road in what is now present-day Centereach. On the property, which was described as "a wilderness covered with trees," he erected a 1.5-story, five-bay saltbox house with a center chimney and a circular brick cellar. Isaac was married to Phebe Overton (1767–1850) in 1788, and they were living here when their son Isaac Jr. was born in 1793.

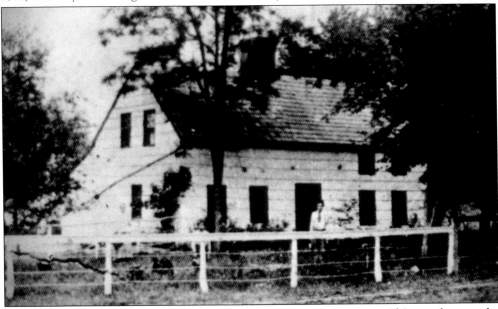

Located on the northeast corner of Middle Country Road and Hammond Lane, this was the home of Mowbray Hammond (1799–1876) and his wife, Laura (1800–1888). The Hammond genealogy relates that on January 1, 1821, Mowbray and his brother Jason married two sisters, Nancy and Laura Hallock. Both couples continued to live near each other in New Village; Laura and Mowbray were still living here at the time of the 1870 census. By 1900, the Frederick Emery family lived here.

from *A Hawkins Genealogy*, p.29

An Inventory of the Personal Estate Belonging to John Hawkins, Late of Brookhaven, & Co. of Suff., deceased Viz.

A Grind Stone	.8	1 Plow	2.	1 Dining Table	.8
1 pair Cart Wheels	.16	2 Cart Clevices	.4	1 Looking Glass	.4
3 Barrels	.3	1 Lot of Wood on the Ground	2.4	3 Water Pails	.4
1 Dutch Wheel	.16	1 Ox Cart	5.	Sundries of Pewter	.8
1 Ox Sled	.4	1 Axe and 2 Hoes	.4	Tin Ware	.4
1 Pleasure Shay	3.	1 Pair of Stears	12.	Earthenware	.2
4 Sheep	1.12	1 Ditto Oxen	10.	1 Pot and Kettle	.6
40 Bushels Corn	10.	2 Horses	2.	2 Tramels and Tongs	.16
40 Ditto Rye	14.	2 Ox Yolkes	.10	3 Beds, Bedsteads e/b	7.
2 Loads of English Hay	9.	1 Ox Chain	.8	1 Cutboard and Linnen	1.12
1 Ditto Straw	.16	1 Chain Clevice and Whipple Tree	.4	1 Table and Stand	.2
1/2 ton of Hay	1.4	4 Shoats	2.8	1 Churn, Knives & Forks	.4
1 load of Top Stalks	1.4	1 pr. of 2 year old stears	5.	1 Tea Kettle and Frying Pan	.4
1 Fork, 1 Rake and Flails	.6	1 Pyed Heifer	3.	1 Loam and Rigging	.8
1 Crackle	.3	1 Black Ditto	2.10	Robes	.4
1 Cutting Box	.8	1/2 Tons of Salt Sedge Hay	3.	1 Hollow Tree and Old Iron	.2
1 Ladder	.2	2 Barrels of Cyder	1.12	1 Fire Lock	.12
1 Load of Cut Stalks	.4	1 Empty Barrel	.4	3 Sythes & Cradle	.8
1 Lot of Flax	.4	1 Cheese Press	.3	1 Hogshead & half Bushel	.1
1 Ox Harrow	.3	2 Bushels of Potatoes	.6	3 Flour Bags	.3
5 Acres of Rye on the Ground	4.	1 Meat Cask	.6	1 Woolen Wheel	.1
1 Work Bench	.1	1 Beef Barrel	.1	1 Cow	2.
Manure in the Yard	.16	1 Fat Tub	.1	1 Soap Barrel	.1
6 Turkeys	.18	Beetles and Wedges	.4	1 Lot of Combustibles	.2
3 Hogs in the Pen	7.14	5 Acres of Rye southward	4.	1 Do. of Ashes	.2
				5 Chairs	.8
					130.17
				1 Bridle & Saddle	.1
				1 Cord Wood on the Landing	4.
				1 Chest and Clothes	2.
					136.18 is Dols Centz
					342.25

John Hawkins (1750-1800) a great-grandson of Zachariah and Mary Hawkins served as a private in the American Revolution taking part in the Battle of Long Island, August 26-28, 1776. John Hawkins moved from Setauket to New Village with his wife and young children. He died in 1800 and the inventory of his estate reveals a prosperous household with several vehicles, furniture, cooking and dining utensils, clothing, tools, farm animals, crops, and cordwood.

We do certify the foregoing Inventory was taken the 10th day of November 1800 and Price of every article offered by us

Daniel Tooker
James Smith
Williams Hawkins } Administrators
Alexander Hawkins

Zachariah (1639–1699), the patriarch of the Hawkins family in Setauket (then Ashford) was not only an extensive landholder but also one of the community's leading citizens, serving almost continuously as town trustee. His son Eleazer (1688–1772) was a wealthy sea captain whose portion from the salvage of an abandoned ship was sufficient to purchase large farms for each of his sons. John Hawkins, Zachariah's great-grandson and Eleazer's grandson, and his wife, Mary Newton, moved from Setauket to New Village "near Mooney Ponds in a locality called the Wolfhole." A 1905 atlas identifies Wolfhole as situated off Holbrook Road south of Middle Country Road. The 1800 inventory of John Hawkins's personal estate shows a prosperous household with several vehicles, furniture, cooking and dining utensils, clothing, tools, farm animals, crops, and cordwood. While his estate was valued at only $136.18, it must be noted that the total livestock appraisal of four steers, two oxen, two horses, two heifers, three hogs, and one cow was less than $50.

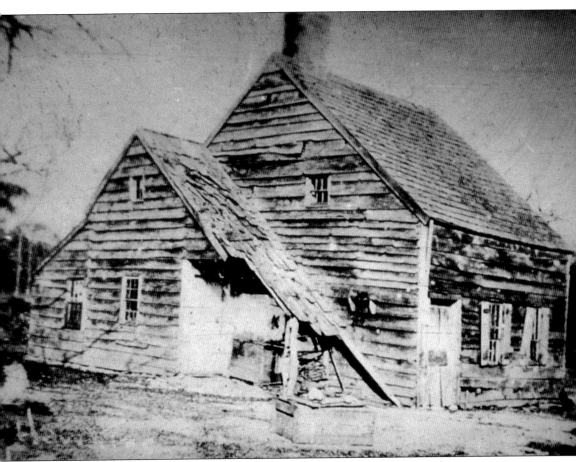

The homestead of several generations of the Hawkins and Smith families, this structure was built in the late 1700s on the north side of Middle Country Road in the vicinity of present-day Ronkonkoma Boulevard. It was originally the home of Azariah Hawkins (1761–1845) and his wife, Mary Green Hawkins. A grandson of Capt. Eleazar Hawkins, Azariah was a farmer and one of the two first deacons of the New Village Congregational Church when it was established in 1815. The home appears to have been passed on to his daughter Elizabeth and her husband, Lemuel Smith. The 1870 census shows their son Azariah Hawkins Smith and his wife, Eliza Terry Smith, and their sons, Elbert F. and Scudder T., living there with their two mothers-in-law, Betsy Smith and Catherine Terry. The last listed homeowner was Scudder Smith (1855–1939).

During the American Revolution, Samuel "Horseblock" Smith operated an inn on the southwest corner of Hawkins Avenue and Middle Country Road. A Smith genealogy relates that on March 2, 1806, Smith sold the inn and the land to Titus Gould. In 1836, Judge Nicoll Floyd testified in court in a boundary dispute action that he was well acquainted with the roads in the area, and he knew the location of the Titus Gould Tavern. It appears part of the tavern was dismantled and moved to another location. When Rev. Otis Holmes became the pastor of the New Village Congregation Church in 1868, he purchased 45 acres from Gould. The house below was probably built by Holmes and enlarged over the years by the Howell and Pulin families.

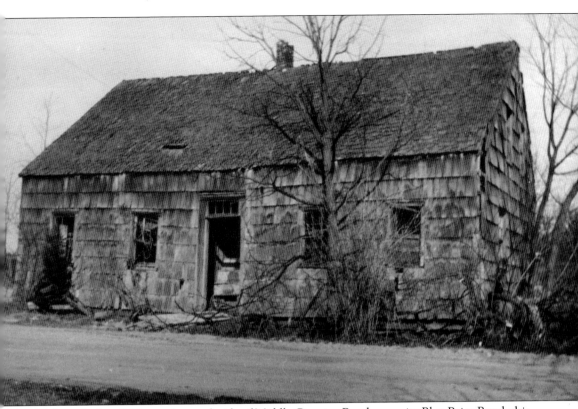

Built in the late 1700s on the north side of Middle Country Road, opposite Blue Point Road, this was the home of Capt. Daniel Roe (1740–1820) and his wife, Deborah, granddaughter of Rev. Nathaniel Brewster, first minister of Brookhaven Town. Roe fought in both the French and Indian War as a lieutenant and in the Revolutionary War as a captain. Fearing captivity by the British, Roe and his family were among the refugees who fled to Connecticut for the seven years of war. Upon returning to Westfield (Selden) in 1783, he continued to farm and be active in community affairs, serving as president of the Brookhaven Board of Trustees from 1798 to 1800. In 1870, the house was purchased and moved by Charles Dare as a residence for his family. On January 20, 1963, the house was torn down, its salvageable boards saved, and the remainder burned.

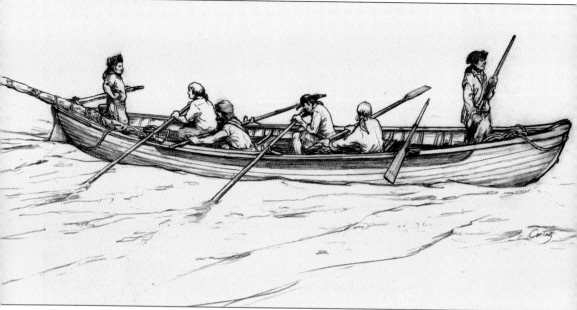

Faced with a lack of warships during the Revolution, the American patriots employed many smaller civilian watercraft to help disrupt British naval and land operations. On Long Island Sound, whaleboats often acted as a "mosquito fleet" to annoy and harass the enemy. As the Long Island refugees had knowledge of the landing spots as well as roads and trails, they were especially well suited to take part in these diversionary tactics. On September 20, 1776, Capt. Daniel Roe commanded a whaleboat expedition from Saybrook, Connecticut, to Brookhaven to bring members of his family and those of several other refugees to Connecticut. Later that year, he participated in an additional whaleboat raid to secure and transport the effects of Colonel Floyd and others across the sound. Another whaleboat raid in November 1780, commanded by Maj. Benjamin Tallmadge, captured Fort St. George at Mastic, New York, and burned 300 tons of hay that the British had collected at Coram. (Courtesy of Ed Cortez.)

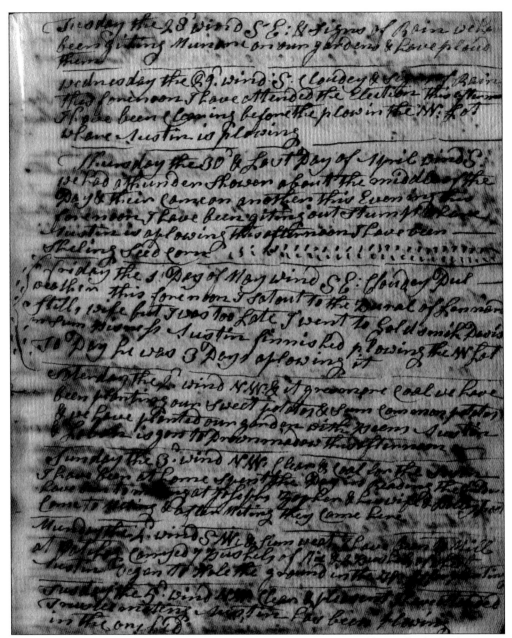

When it was discovered by Daniel Roe's great-grandson Benjamin Franklin Hallock of Lake Grove, all that remained of Roe's diary was his handwritten record of the years 1806–1808. Published in 1905 by Albert Seelye Roe of Connecticut, another great-grandson, those meager excerpts testify to the Long Island farmers' reliance on favorable winds, weather, and tides for the planting and harvesting of rye, wheat, and flax and the cutting and hauling of loads of cordwood to the north shore for shipment to New York City and Connecticut. The diary's subsequent pages of recorded visits by relatives and neighbors further attest to community life on Long Island in the early 19th century. (Courtesy of the East Hampton Public Library Long Island Collection.)

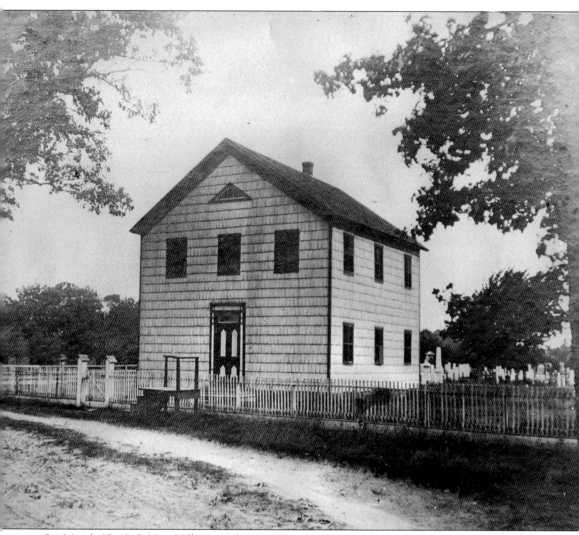

On March 27, 1815, New Village residents met at the home of Jeremiah Wheeler to establish a Congregational church. In 1818, a meetinghouse plan was drafted. Erected in 1818, on the north side of Middle Country Road, the building served first as a union church—one half owned by the Congregational society and the other half by the Baptist and Presbyterian societies. Sunday mornings would find the worshipers seated on rough planks across sawhorses with no backs or cushions. Lunches were brought along to sustain them through the afternoon service. Eventually, the Presbyterians united with the church in Setauket, and the Baptists relinquished their claim. In 1845, the church was incorporated under the name First Congregational Church of New Village. As the community expanded in the 1950s, church membership grew as well. Land was purchased, and a new church building was erected and dedicated in 1963. In 1970, the Town of Brookhaven purchased the original church building for $1 and restored it. Now operated as a museum, it is still the scene of an occasional summer or fall wedding.

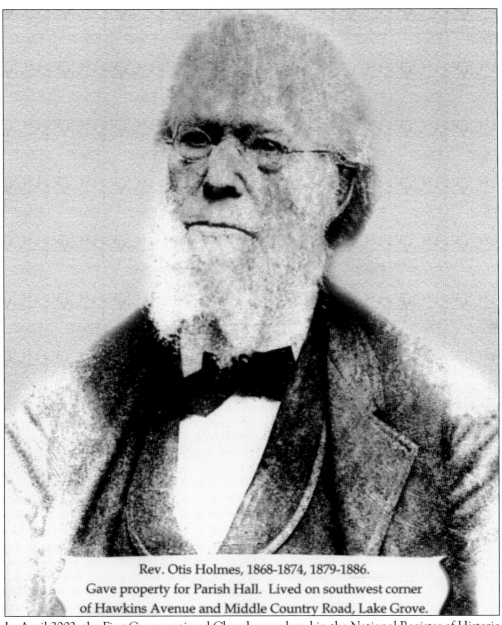

Rev. Otis Holmes, 1868-1874, 1879-1886.
Gave property for Parish Hall. Lived on southwest corner
of Hawkins Avenue and Middle Country Road, Lake Grove.

In April 2002, the First Congregational Church was placed in the National Register of Historic Places. Many pastors have ministered to this congregation over the past 200 years. Perhaps none was more important than the Rev. Otis Holmes, who served from 1868 to 1874 and again from 1879 to 1886. Settling in New Village in 1868, he purchased land from Titus Gould on the four corners of Middle Country Road and Stony Brook Road. For many years, the site was known as Holmes Corner. Before his retirement, Holmes expressed a wish for the church to have a parsonage built for future clergy and offered to donate land to be used for that purpose. His offer was accepted, and the parsonage was completed in the spring of 1886. Truly a generous man, Holmes refused aid from the Home Missionary Society to supplement the church income and used his own financial resources to make up any deficit. Reverend Holmes is buried in the Holmes family plot in the New Village Congregational Church cemetery.

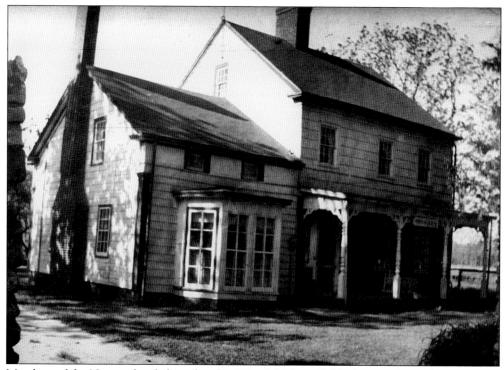

Members of the Norton family have lived in Westfield (now Selden) since the mid-1700s. Brion Norton is listed in the 1790 census on the same manuscript page as neighbors Daniel Roe and Nathaniel Longbotham. Richard Norton is mentioned in Roe's diary as his closest neighbor. The house pictured above was built in the 1800s and inhabited by Norton family members into the first decades of the 20th century. The image below shows the house and the numerous outbuildings surrounding it. In the late 1800s, Albert Norton was the owner and operator of the Wheelman's Rest for bicyclists. After the property changed hands, it was, at onetime, an antique shop. In the 1980s, efforts were made to preserve the building. However, it proved to be structurally unsafe and was demolished.

Two

FARMING COMMUNITIES
1850–1900

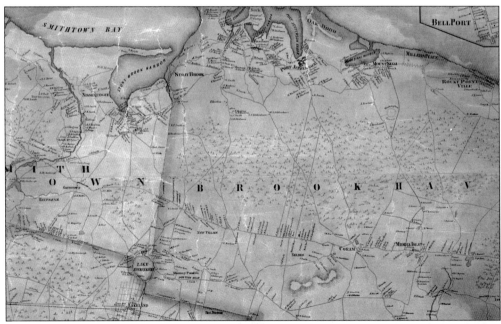

One of the first detailed maps produced of Suffolk County, this section of the Smith and Chace map focusing on middle Brookhaven Town provides the names of property owners and prominent homes. The map clearly shows that while there has been development along Middle Country Road, the area between the north shore and the middle of the island remains undisturbed.

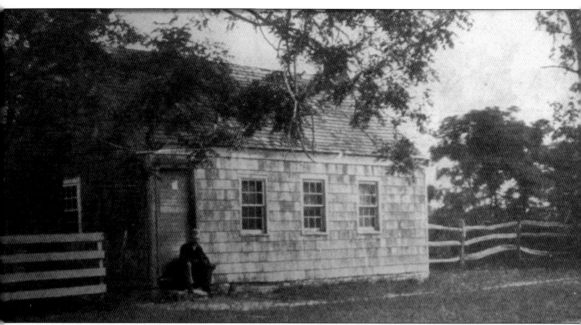

The Westfield School District (originally No. 25) was created in 1815 to educate the neighborhood children previously attending schools in New Village and Coram. The first Selden School, built in 1820, was located on the north side of Middle Country Road on land purchased for $2 from Davis Norton. It remained in use for 50 years. By the 1860s, there were approximately 40 students in attendance. In 1870, the school was sold to a neighbor who reportedly used it for a workshop. In the same year, an additional acre of land was purchased from the Norton estate for $100. The district paid half and the eldest Norton son paid the rest for the construction of the second one-room schoolhouse, pictured here. It remained in use for another 28 years until it was sold and used as a cow shed and barn on the property of Richard Henry and a third schoolhouse was built. (Courtesy of Barbara Russell.)

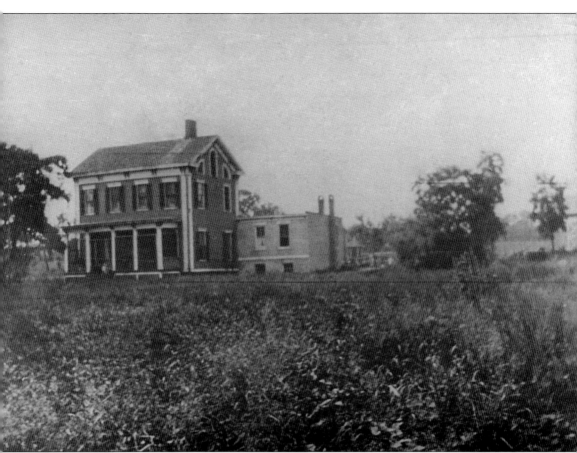

Genealogical records trace members of the Longbotham family as Brookhaven residents listed as far back as 1775. Nathaniel Longbotham is listed in the 1810 census along with his Westfield neighbors Daniel Roe and David and Richard Norton. The stately Longbotham home, located on the south side of Middle Country Road, was most likely the home of Henry Longbotham. Henry, a farmer, and his wife, Mary, are listed in the 1850 census along with son William, 26, twins Thomas and Jacob, 19, daughter Mary, 16, and son Horace, 13. They are on the same document page as Selden residents Davis Norton, Minor Norton, and Charles Dare. A Longbotham private graveyard is recorded as southeast of the Selden Schoolhouse and beside the Long Island Lighting Company (LILCO) and New York Telephone Pole No. 408 in Selden. In later years, the home was the residence of the Forsyth family.

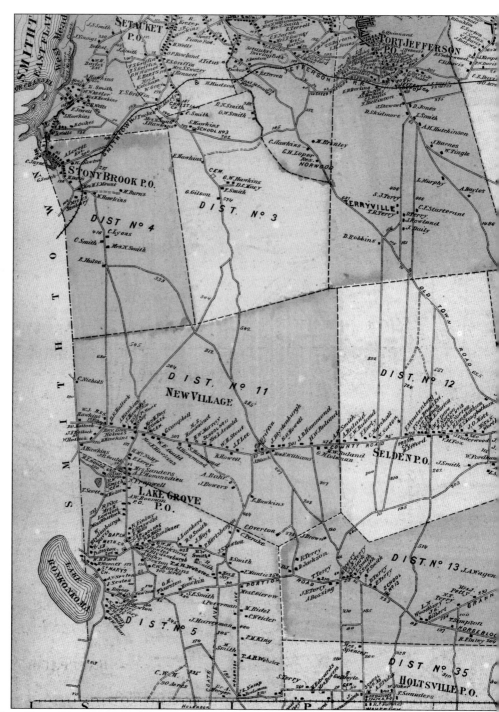

An atlas of Long Island published in 1873 by Beers, Comstock, and Cline identifies the property owners as well as the schools, churches, and cemeteries in the communities of Lake Grove, New Village, and Selden. While Lake Grove shows development along present-day Hawkins Avenue, development in New Village and Selden remains concentrated on the main road and predominantly on the north side. Some additional north-south access roads have appeared. However, most are

24

unnamed and probably were little more than wagon paths. While Hammond, Hawkins, and Hallock are names familiar from earlier times, those of Dare, Murray, Marshall, Coleman, and others reflect a growing community. Listed in the atlas directory and also cited on the map is Lake Grove carriage maker R.W. Smith.

25

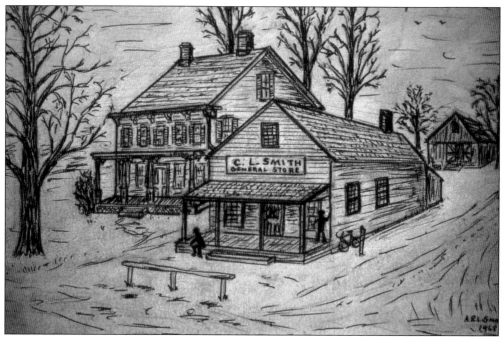

Established in 1873, Charles Smith's general store was located in Lake Grove on the southwest corner of Hawkins Avenue and Moriches Road at the intersection now known as Five Corners. Although the structure burned in 1892, it is credited with being the first general store operating in west central Brookhaven. This depiction was drawn in 1968 by artist Art Smith, whose signature can be seen in the far right corner.

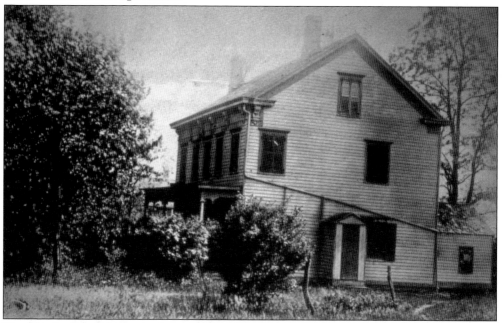

The Charles Smith home, built in the 1860s on the southwest corner of Hawkins Avenue and Moriches Road, was still standing when this photograph was taken in 1915. It is most likely the same structure portrayed to the left of the general store in the drawing by Art Smith.

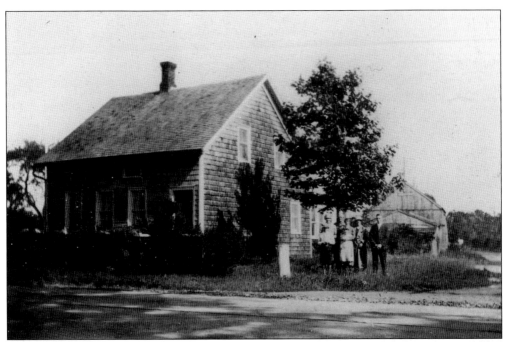

In the course of two centuries, three families lived in this house and worked on the farm on the southeast corner of Middle Country and Horseblock Road. First, the Howell and Williams families were there in the 19th century, and the Henry Duffield family was there in the 20th century. The image above is believed to show the Henry Duffield family: Henry, Clara, and their son, Harry. The photograph below features a freshly painted house with, most likely, members of the Duffield family in early 20th-century dress.

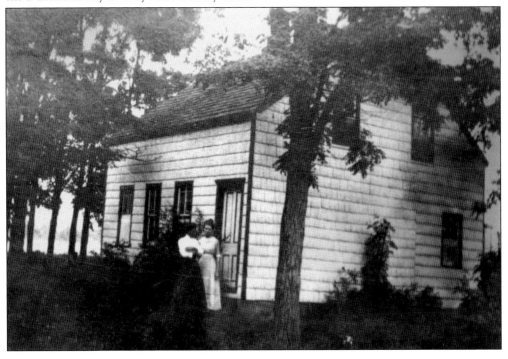

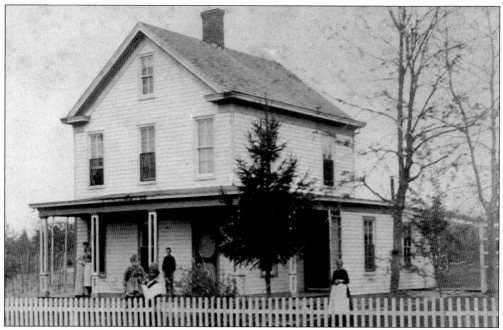

Likely built in the latter part of the 19th century and located on the south side of Middle Country Road and west of Boyle Road, this was the home of Isaac and Emma Duffield and their four children—Clarence, Maybelle, Raymond, and Nora—three of whom are pictured here on the left. The woman to the right in the photograph is most likely Sarah Duffield, Isaac's widowed mother, who lived with them. As Selden's road overseer for a number of years, Duffield was responsible for keeping the unpaved roads passable in all seasons. (Courtesy of Barbara Russell.)

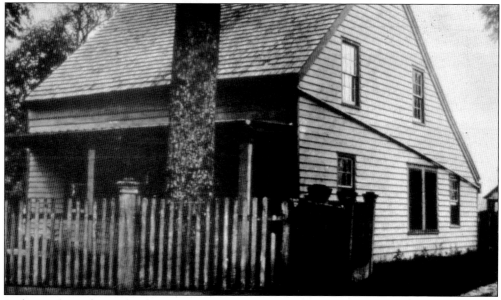

Built in 1858 on the south side of Middle Country Road opposite the First Congregational Church, this was the home of New York City physician and editor Abijah Ingraham, his wife, Maranda, and their family. It is possible the family moved here after their daughter Maranda married Charles A. Reeve of New Village. In the 1900s, the home was owned by Edward and Edith Sanders.

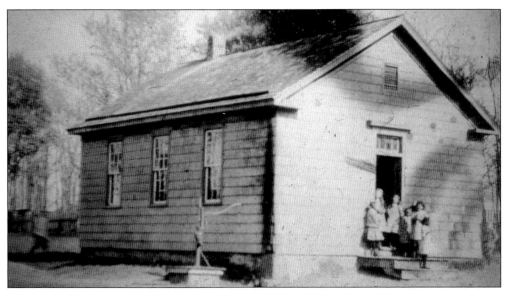

Reportedly, the first New Village School was located on Middle Country Road across from present-day Rustic Road. In 1858, at the annual school meeting, it was decided to erect a new schoolhouse. In 1860, an acre in the southeast corner of Henry Murray's farm was purchased for $75, and the schoolhouse was built for an additional $400. In 1872, there were 15 New Village students, and the teacher's salary was $300 per year.

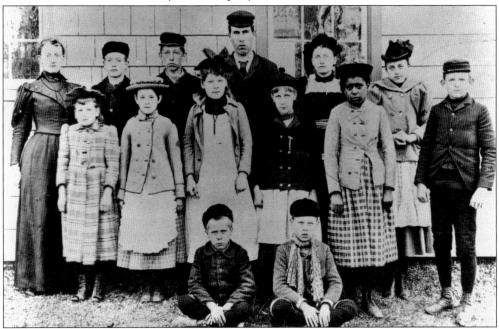

In the spring of 1895, the 13 students at the New Village School were photographed. In 1936, the *Mid-Island Mail* printed a copy of the photograph identifying both students and their teacher; from left to right are (first row) Louis Bowers and Herbert Blydenburgh; (second row) Lina Wheeler (Newton), Minnie Geislinger (Kemp), Mamie Blydenburgh (McCarthy), Amelia Bowers (Fuchs), Laura Brown, and Herbert Hallock; (third row) Clara Hawks (teacher), Edward Woodcock, William Stierle, Sidney Hawkins, Lena Hallock (Steen), and Evelyn Coleman (Wilkinson).

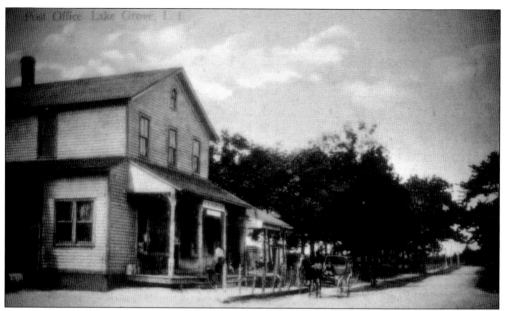

In 1892, Samuel Hawkins resigned his teaching post in East Marion to open a general store. Built in 1893 on the corner of Hawkins Avenue and Moriches Road, the two-story structure was also the district polling place. Newspaper election notices announced upcoming voting "in the Hall over the store of Samuel N. Hawkins." In 1900, Samuel Hawkins became Lake Grove's postmaster, a position he held for the next 16 years. While the above postcard image shows a horse and carriage waiting outside the truly general store, the photograph below portrays a quiet, winter scene. While the store's proximity to the streets of the intersection was very convenient in the horse-and-buggy era, the advent of the automobile made that same proximity a hazard, and the nearly 50-year-old landmark had to be demolished.

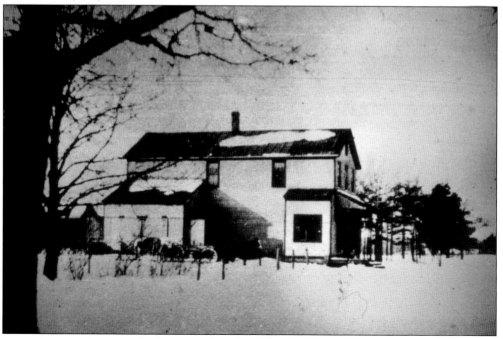

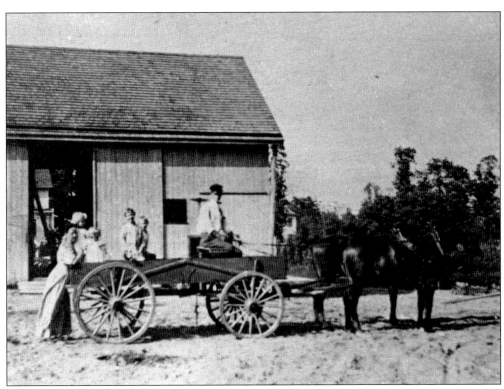

This scene shows the Dare family farm. Located on the north side of Middle Country Road, it was most likely purchased in the 1840s by Charles Dare. Charles was born in Lancashire, England, in 1806. He and his wife, Mary Ann Hall, raised 12 children here. By the 1870s, the farm had passed into the hands of their son Samuel.

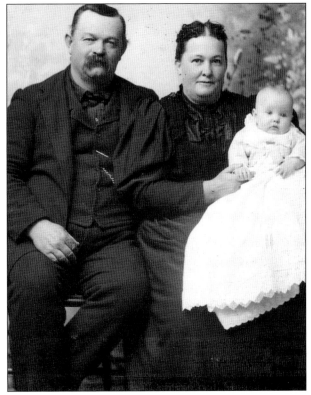

This posed photograph of Samuel and Henrietta (Wicks) Dare and their daughter Pauline Dare (Still), the ninth of their 10 children, was taken in 1896. Samuel was a Civil War veteran, having enlisted in the Union army at the age of 16. A prominent member of the Selden community for many years, he was a member of the Brookhaven Board of Trustees, serving as its president from 1894 to 1897.

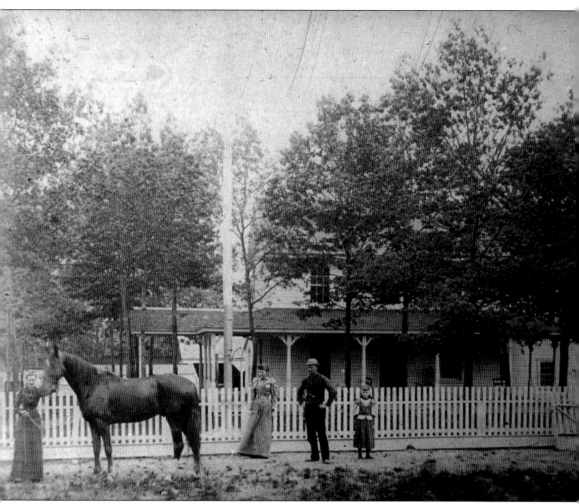

By 1880, Lewis Irving Overton, his wife, Matilda, and family were living in this house in Selden, reported to have been moved from Coram to the top of Selden Hill near the Mott and Longbotham families. Overton was a great-grandson of Revolutionary War hero Daniel Roe, and his grandmother Ruth Roe Overton was the seventh child of Daniel and his wife, Deborah. Although only nine of Irving and Matilda's 15 children survived to adulthood, many of their descendants have been longtime residents of the area. Included in that list are David Overton, former longtime Brookhaven town historian; Alvin R. Smith, Brookhaven police officer and amateur photographer, many of whose photographs are included in this volume; Muriel Williams Overton, former New Village Congregational Church historian; and Joyce Williams Bogin, retired Middle Country librarian, present historian of the New Village Congregational Church, and great-great-granddaughter of Lewis Irving Overton.

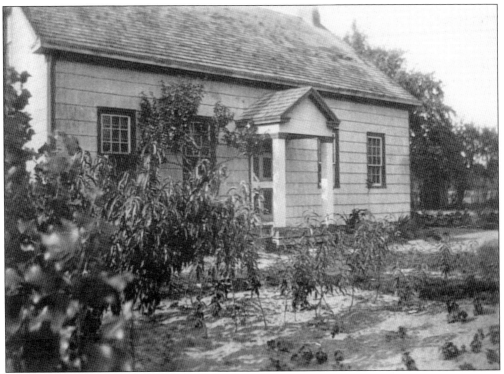

A deacon in the First Congregational Church of New Village, James Davis Hammond (1825–1908) was the grandson of the first Centereach residents—Isaac and Phebe Overton Hammond. James Davis, his wife, Sarah Hawkins Hammond, and their four daughters lived in this home on Middle Country Road, 600 feet east of Hammond Avenue.

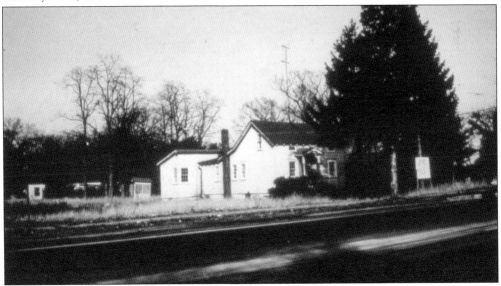

Located on the north side of Middle Country Road, almost opposite Horseblock Road, this was originally the New Village home of farmer Ichabod Blydenburg, his wife, Hester, and their children, Joseph, Frederick, and Wilbur, in 1870. By 1910, the youngest son, Wilbur, and his wife, Mary, had taken over the farm, and Hester was residing with them.

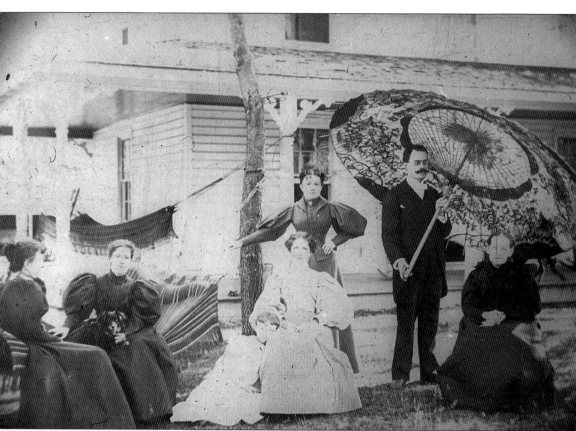

The Byrne family summer residence, Pinelands, was on a 100-acre site on the north side of Middle Country Road on Selden Hill. As indicated from the photograph, the family entertained in style. An account of a reception for 150 guests printed in the *Port Jefferson Echo* in 1894 describes the array of potted plants and cut flowers that decorated the parlors, while the lawns were illuminated with Chinese lanterns in varied colors. The flagpole was adorned with red, white, and blue lanterns. Music, dancing, ice cream, and cake were enjoyed by all. (Courtesy of Barbara Russell.)

Three

20TH-CENTURY GROWTH
1900–1950

In this early 20th-century photograph of rural Middle Country Road, the New Village Congregational Church (left) is partially obscured by trees. The road, seen in this view looking east, is unpaved. There appears to be no traffic, and lighting and telephone poles are rare. While farming was still the main occupation of most of the New Village households, other jobs included carpenter, wagonmaker, blacksmith, teacher, compositor, stonecutter, and pencil maker.

Taken around 1910, this view of a rural Middle Country road in Selden fits with the 1901 description of the area in the *Port Jefferson Echo* written by resident Fred Dare. He notes that Selden represents a "live little village in which there is a post office, district school and a store . . . with a population of about one hundred, most of whom are market gardeners," including J.T. French, Samuel Dare, A.R. Norton, David Duffield, S.Y. Mott, J. Grant Smith, H.S. Scott, W.W. Smith and Jesse Vanderwood. Other Selden occupations and businesses were operated by J. Byrne, a breeder of thoroughbred fowl; Joseph Black, a blacksmith; Edward Osborne, mail carrier; and Charles Terrill, grain thresher and wood sawyer. Samuel Dare was a flour, feed, grain, and fertilizer agent, and A.R. Norton was an agent for the Ohio Cultivator Co.

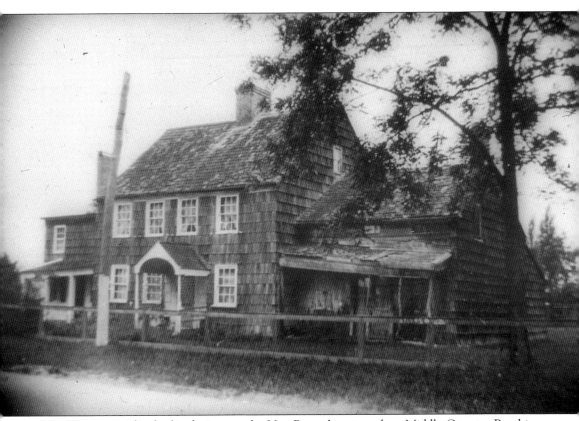

The 1873 Long Island atlas designates the Van Brunt homestead on Middle Country Road in Selden, at the corner of what is now Abinet Court and Middle Country Road. The last of the Van Brunts to occupy the house was a couple lost at sea on a trip to England in the late 19th century. The property then came into possession of a niece, Sarah French, Selden's postmistress for a number of years. John Abinet, who owned the house in the 20th century, ran a pig farm on this property. In 1938, Abinet was found guilty of having violated a town ordinance, which limits the number of pigs on a farm to 75. In July 1937, there were more than 200 pigs on the Abinet farm. The building was destroyed by fire in 1939.

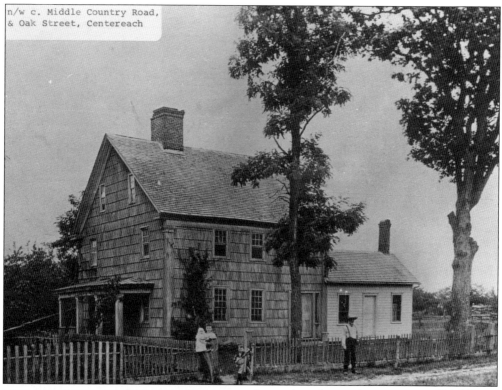

Located on the northwest corner of Middle Country Road and Oak Street in New Village, this home and farm is believed to have originally been one of the Hammond homesteads. In 1865, it belonged to Henry Murray and his wife, Maranda Ingraham Murray. By 1900, their son William Henry Murray, his wife, Flora, and their sons, Arthur and Harold, lived here.

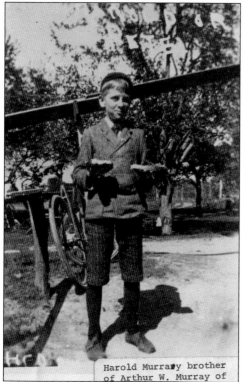

Harold Murray, brother of Arthur W. Murray of

Taken in the early years of the 20th century, this photograph is of a young Harold Murray, son of William Henry and Flora Murray. In his Sunday best, he gives all the appearances of a young boy about to get into mischief. His bicycle is parked to the side, and he seems to have two tarts in his hands. (Courtesy of Barbara Russell.)

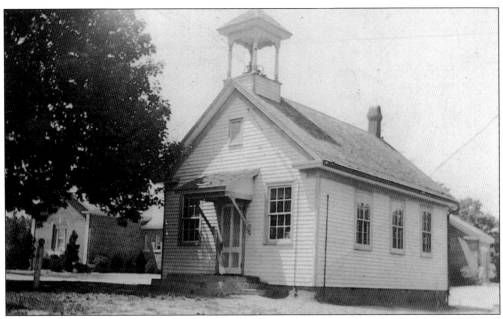

Built in 1898, this one-room schoolhouse was located on Middle Country Road on land purchased from the Norton estate. It served the community for 37 years until the growth of the school-age population necessitated the building of a new facility. The 1935 Selden School, which replaced it, can be seen in the background.

REGISTER OF ATTENDANCE in School District No. 12 Town of Brookhaven

NAMES OF PARENTS OR GUARDIANS.	Pupils No.	NAMES OF PUPILS OVER 5 AND UNDER 21 YEARS OF AGE, RESIDING IN THE DISTRICT.	NAMES OF TOWNS IN WHICH PUPILS RESIDE.	Age.	DATE OF ENTRANCE.
		Annie Bixby		19	Sept.
Joseph Black	1	Annie Black	Brookhaven	8	
Black	2	Edith Black		5	
Samuel Dare	3	Laura M. Dare		7	
" Dare	4	Fred Dare		12	
" Dare	5	Ernest Dare		9	
" Dare	6	Mora Dare		5	
David Duffield	7	Retta Duffield		10	
"	8	Ernest Duffield		13	
Albert Norton	9	Lizzie Norton		12	
Irving Overton	10	John B. Overton		7	
"	11	Webster Overton		9	
"	12	Annie Overton		11	
Samuel Palmer	13	Billy Palmer		9	
"	14	Robert Palmer		12	
"	15	Herbert Palmer		7	
Edmund Ruland	16	Nellie Ruland		13	
John F. Taft	17	Harry Taft		8	22
Frank Earley	18	Nellie Smith		4	Oct. 12
Bruce Duffield	19	Effie Smith		11	Nov. 9
Nelson Norton	20	Axel Hanson		12	23
Jesse Smith	21	Grant Smith		6	Nov. 30
Irving Overton	22	Frank Overton		14	Oct. 7

The 1903–1904 Selden School attendance register records the names of the 22 students enrolled and those of a parent or guardian. It documents the length of the school term, holidays, snow days, and vacation times. A checklist of school necessities includes a pail, fire shovel, fire tongs, blackboard, flag, glove, maps of the United States and New York State, a dictionary, and an encyclopedia.

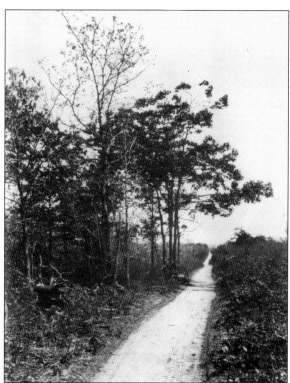

With the late-1800s impetus of the new safety bicycle replacing earlier high-wheeled models, bicycle mania gripped the country. In 1898, the Long Island Rail Road, required by law to carry them for free, transported 176,000 bicycles. One of the dedicated paths created to accommodate riders was a 15-mile-long popular route from Patchogue to Port Jefferson. A close look at the photograph reveals a lone rider along part of that bicycle path in Selden.

In 1899, the New York State Assembly passed the Ellsworth Sidepath Law, requiring bicyclists to purchase licenses for 50¢ per year to use the dedicated bicycle paths throughout the state. Special side path police were authorized to arrest cyclists who failed to use signals or follow laws. (Courtesy of Marc Weiss.)

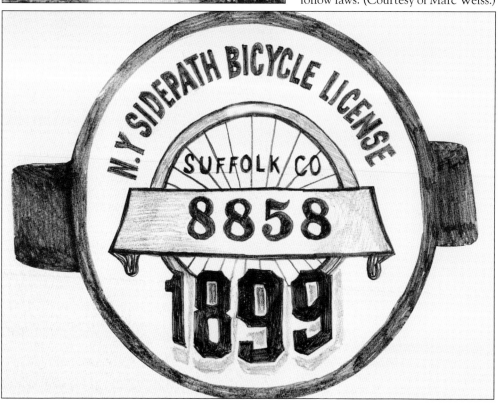

A popular spot along the cross-island bicycle path where bicyclists could rest and order refreshments, the Wheelmen's Rest was owned and operated by Selden resident Albert R. Norton. One of the greatest contributors to the path, Norton donated the right-of-way for the path in front of his extensive property between Selden and Port Jefferson.

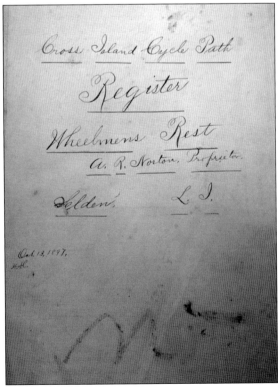

A *Port Jefferson Echo* article from 1900 describes entries in the Wheelmen's Rest register from 1897 when the path was completed. Over 6,000 names had been entered, including bicyclists from all parts of the United States as well as England, France, Denmark, and other countries. Perhaps of more interest are the entries of many Centereach, Selden, and Lake Grove neighbors and ancestors whose signatures recall their lives in the communities. (Courtesy of Barbara Russell.)

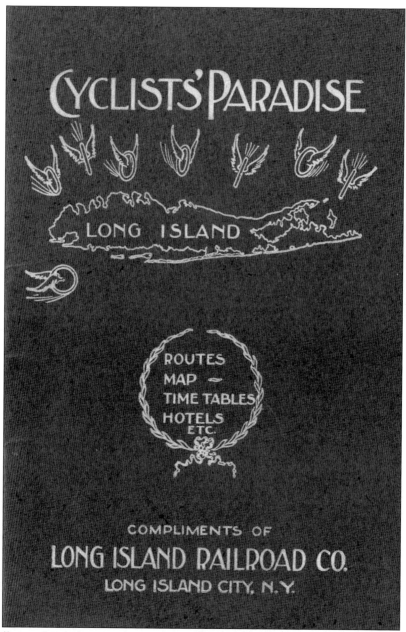

Hal B. Fullerton, local photographer and special agent for the Long Island Rail Road, created a guide for wheelmen, *Cyclists' Paradise*, listing hotels, beaches, and local events to promote tourism and settlement here. Events of the summer of 1899 included the midsummer meeting of the League of American Wheelmen, a cyclist's carnival and clambake on the Great South Bay, and a mile-long bicycle-train speed race. The 1899 summer carnival concluded in Port Jefferson with a fire department parade and firemen's contest. Club members rode special side paths to compete at each of these events. *Cyclists' Paradise* includes a detailed map that illustrates scenic routes and rates each bicycle path by condition. Railway timetables and telephone service locations are included for the convenience of the tourists and businessmen who vacationed with their families over the summer. (Courtesy of Kristen Nyitray.)

As patriarch of the Norton family, Albert was a landowner, Selden postmaster, and one of the famous Selden melon growers. In 1893, a *Port Jefferson Echo* article celebrated the 35-pound watermelon he sent to the newspaper office. However, his obituary in 1915 claims that although a lifelong farmer, "he became known to thousands of bicyclists for . . . the only ice cream and confectionery store on the sixteen mile" path. (Courtesy of Barbara Russell.)

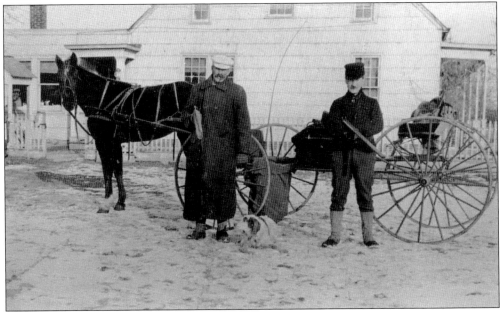

Local newspapers carried reports of residents procuring ducks, pheasants, and other wild game birds for sport hunting widely encouraged by the famous Southside Sportsman's Club, formed in 1866, which promoted the wilds of Long Island as a haven for game. William W. Ruland, shown here outside his Selden home in hunting attire, appears ready for a day of spotting game.

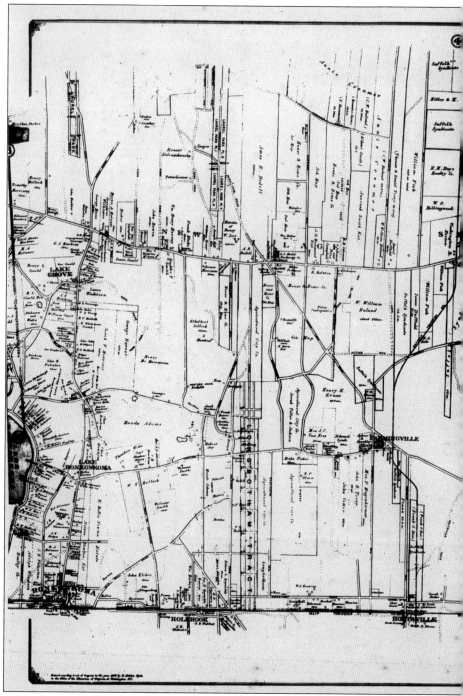

The 1909 E. Belcher and Hyde maps of Middle Country Road evidence changes to patterns of land ownership when compared to the 1873 map. In both the New Village and Selden areas, large tracts have been purchased by development companies such as the House and Home Company, Agricultural City Co., and the Suffolk Syndicate. Laurel Park in New Village appears to have been planned as a housing development. However, agriculture remains a principal occupation,

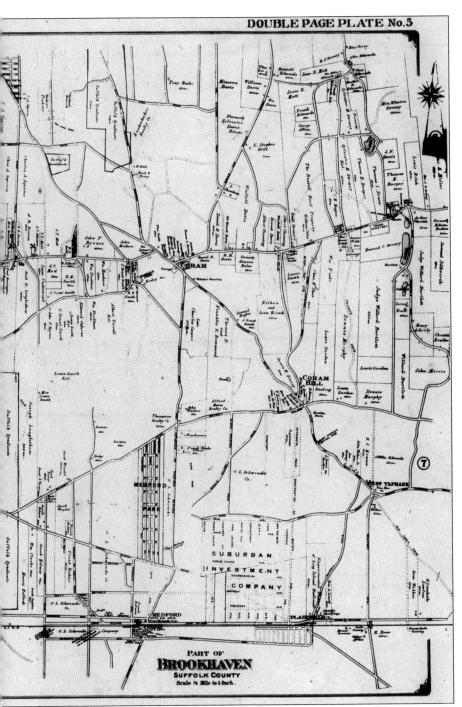

PART OF
BROOKHAVEN
SUFFOLK COUNTY
Scale ¼ Mile to 1-Inch.

with farmers such as Samuel Dare and Samuel Youngs Mott owning large acreage on both sides of Middle Country Road. New roads have been added to the landscape, some such as Boyle and Coleman Roads for new landowners while others remained unnamed or are simply labeled Private Road. Mark Tree Road heading southeast is an uninterrupted roadway joining Horse Block Road in its path to Medford.

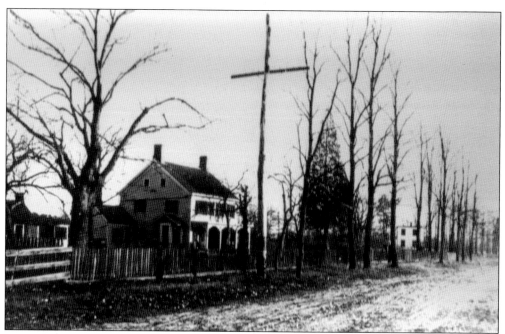

Located on the northwest corner of Middle Country Road and North Washington Avenue, this was the family home of William and Jesse Henry and their seven daughters and one son, who had emigrated from Scotland in 1892. They settled in New Village, where Jesse Henry's brother, Charles Brown, was pastor of the Congregational church.

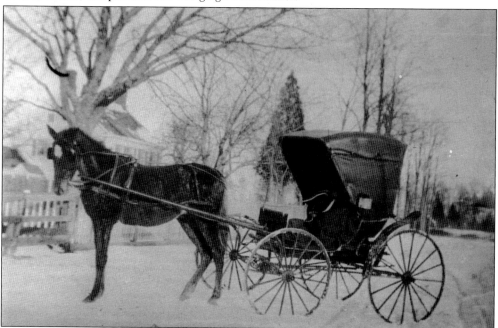

Pictured here in front of the Henry House on a snowy day in the early 1900s, this two-wheeled, horse-drawn cabriolet was a popular means of transportation in the Victorian era. Used as a taxicab in New York City, its shortened name, *cab*, is believed to be the origins of the terms *taxicab* and *hansom cab*.

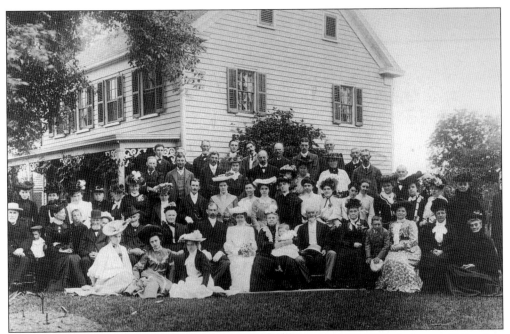

The Henry home was the locale for the wedding of their daughter Wilhelmina, or "Mina," to Bert Terry, son of Hiram Terry of Farmingville. According to the Howell genealogy manuscript, the wedding was attended by "almost everyone in the village" as well as three generations of family members.

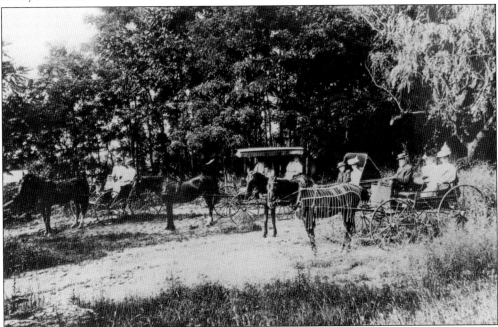

This early-1900s photograph shows members of the Henry family gathered in party attire with puffed sleeves and straw hats for a day's outing at Lake Ronkonkoma. It is believed this photograph and the one at the top of the page were taken by Will Henry, Mina's brother, who was a photographer for the *New York Herald Tribune*.

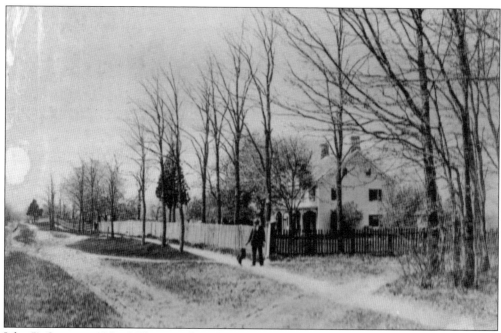

John B. Overton, a New Village resident, listed in various census records as the owner of a livery stable and as the proprietor of a gas station on Hawkins Avenue in Ronkonkoma, is photographed in both these images outside the Henry House. The one above shows him walking his dog on an empty and unpaved, yet picturesque, Middle Country Road in front of a fence surrounding the Henry house. The image below portrays him in traditional chauffeur garb standing alongside his Ford taxi.

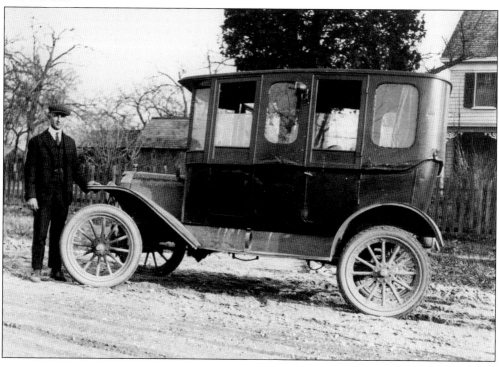

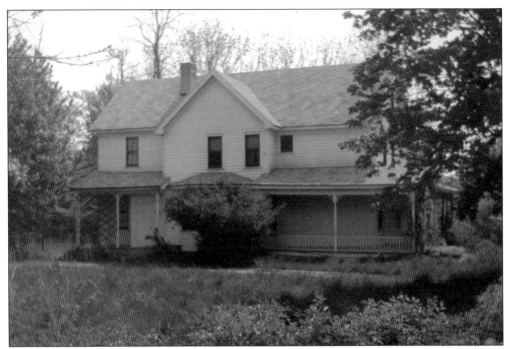

Located in the northeast corner of Middle Country and Stony Brook Roads, this was the home of George Moen, a widower, his sisters Elizabeth Moen and Lavinia Wildman, and his son Francis. Moen, a steelworker in the shipyards, purchased the corner property from Elbert Howell, the son-in-law of Rev. Otis Holmes. In time, the corner looking east on Middle Country Road, formerly known as Holmes' Corner, was called Moen's Corner. In the photograph below, taken around 1910, the house is visible in the left corner. The house was demolished in 1960 and, at present, the site is home to retail establishments. (Above, courtesy of Barbara Russell.)

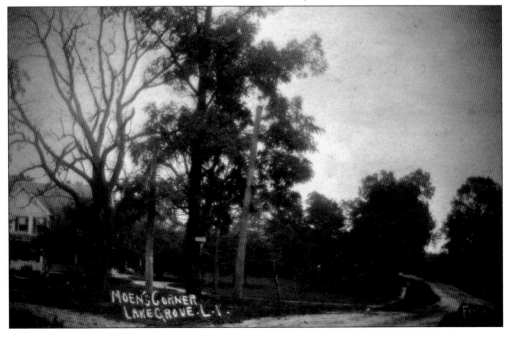

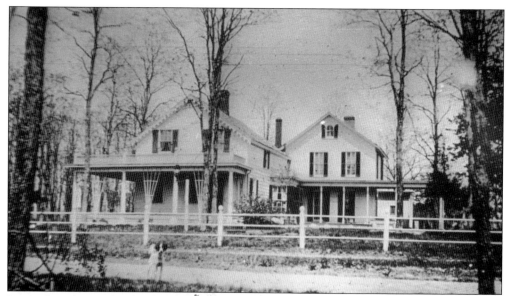

Located on the north side of Middle Country Road, opposite Rustic Road, this home originally belonged to Ambrose and Lavinia Gould in the latter part of the 1800s. It was also home to the Arnold family, and Francis and Marion Craft acquired it between 1920 and 1930. In 1983, it was the site of the Pancake Cottage.

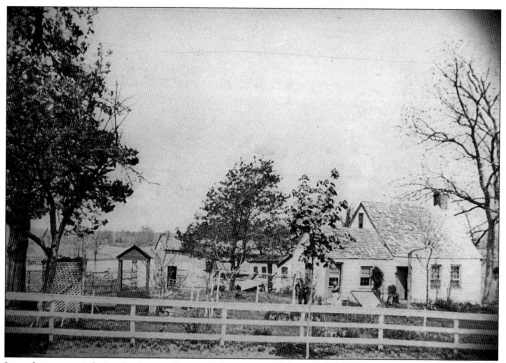

Listed in an article in the *Port Jefferson Echo* as one of the market gardeners of Selden, Henry S. Scott and his wife, Ellen, both emigrated from Denmark. Their farm was located on the south side of Middle Country Road next to land belonging to Samuel Youngs Mott.

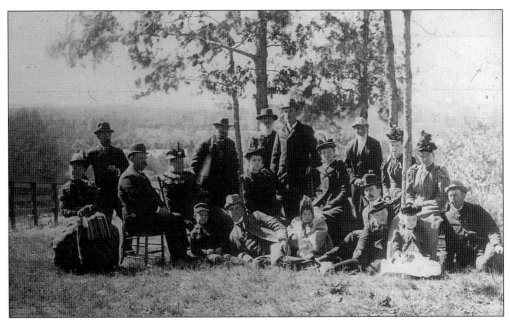

An unidentified group of local residents, possibly the Byrnes, has gathered for an occasion on Selden Hill. Looking at the apparel worn, the time period appears to be the late 1800s when leg-of-mutton sleeves, as the woman on the far right is wearing, were in vogue. Also, hats were the fashion as witnessed by the fancy millinery styles of the women and children. The men, too, are wearing an assortment of Victorian headgear. (Courtesy of Barbara Russell.)

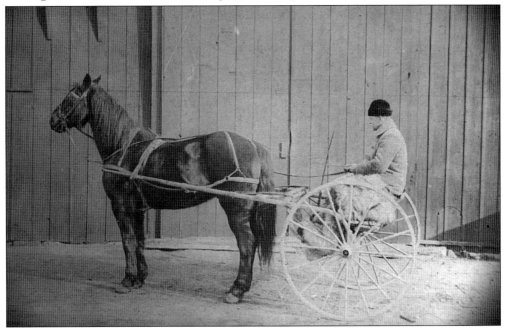

According to the 1910 census, Edward B. Osborne, who lived with his wife, Adeline, and daughter, Abby, on Mooney Pond Road in Selden, owned and operated a farm there. In this photograph, he appears to be driving a racing vehicle, popular in the early 20th century. According to the *Port Jefferson Echo*, Osborne also was an occasional mail carrier.

Located on the south side of Middle Country Road and Coles Road, this was originally the home of Isaac and Hannah Gould. In 1914, it was purchased by Amos Williams and later transferred to his son, Coles. In the late 1950s, the fire department was tasked with setting a controlled blaze to demolish the house to make way for commercial development.

When Amos Williams purchased the farm, he maintained it as a dairy farm with prize cows he demonstrated at county fairs. In 1923, when his son Coles took over the property, he changed the operation to a vegetable farm. In 1983, as farms disappeared from the landscape, the location became the site of McCarville Ford.

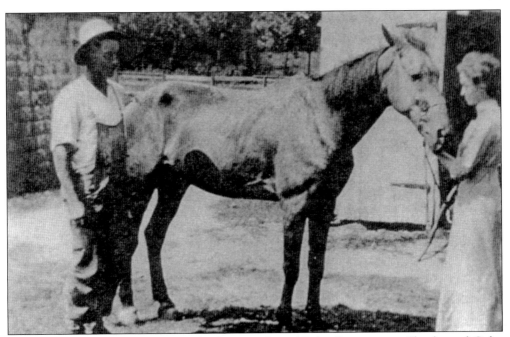

In an early 20th-century photograph of a typical rural Lake Grove scene, Phoebe and Coles Williams are seen admiring a favorite horse at the Williams Farm on Middle Country Road. Horses were still the mainstay of farming as mechanization was just beginning to take hold in rural Long Island.

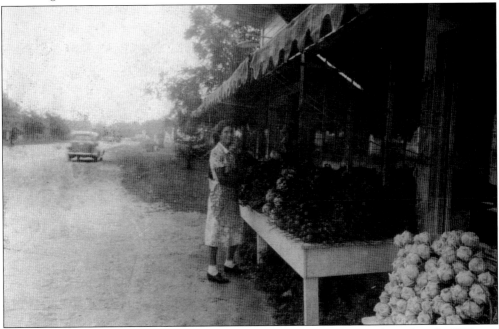

This photograph, showing an as yet unpaved Middle Country Road, was taken when the Williams property had switched from dairy farm to a vegetable farm. Lake Grove resident Jennie Manitta can be seen admiring the display of locally grown vegetables produced for the extensive Williams Farm Stand.

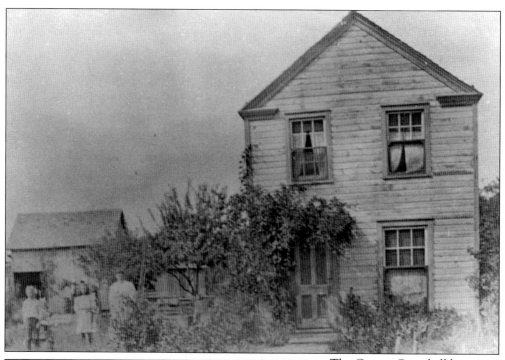

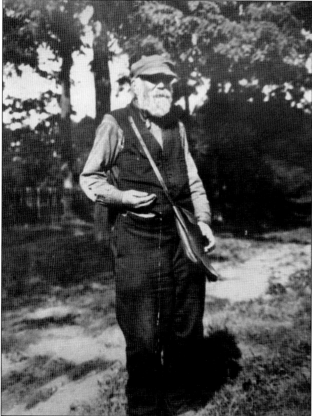

The George Campbell home was located at the northwest corner of Wood and Middle Country Roads. George Campbell Sr., who was born in Scotland in August 1818, came to the United States in 1849. Here, he and his wife, Mary, raised six children. George was considered the law for the area, "a typical old western constable" who never carried a gun but whose commanding presence kept the peace. (Courtesy of Barbara Russell.)

In the early 1900s, before the advent of house-to-house mail delivery in the area, New Village resident James Campbell became a self-appointed mail carrier. For 1¢ for each piece, he would deliver mail to residents along Middle Country Road.

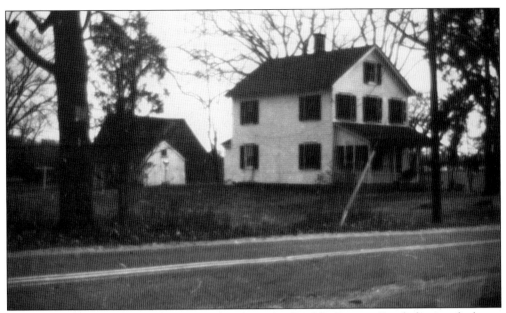

Located on the south side of Parsnip Pond Road, south of Middle Country Road, this was the home of Benjamin Franklin Hallock (1850–1931) and his wife, Mary Youngs Hallock (1854–1929). Born in Lake Grove, the son of Mary Halsey Rogers and Daniel Roe Hallock, he was a great-grandson of Capt. Daniel Roe of Selden, whose diary (page 17) he discovered in the Roe family papers. An 1874 graduate of Cornell University, where he studied agriculture, Hallock returned to Lake Grove to farm his father's land. He was active in the Methodist Episcopal church and president of the New Village and Lake Grove Temperance Society. The view in the image below, taken in 1966, looks southwest on Middle Country Road.

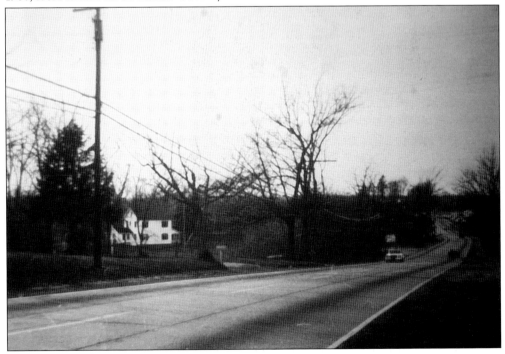

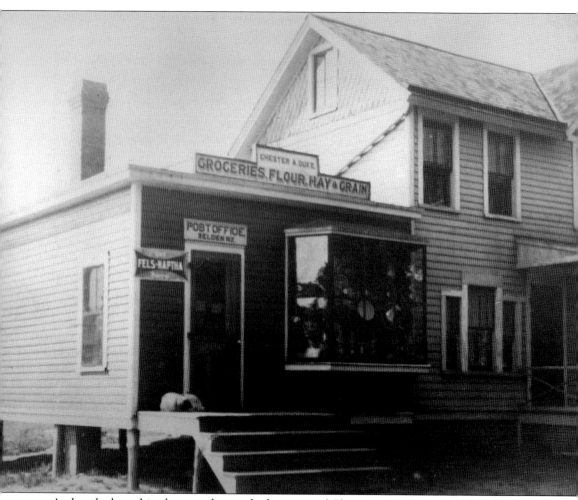

A close look at this photograph reveals the name of Chester A. Duke, the Selden postmaster from December 1911 to January 1922. Located on the south side of Middle Country Road and between South Evergreen and Selden Court, the building also served as a retail emporium selling groceries, flour, hay, grain, and even Fels-Naphtha soap, which was used as a home remedy for exposure to poison ivy.

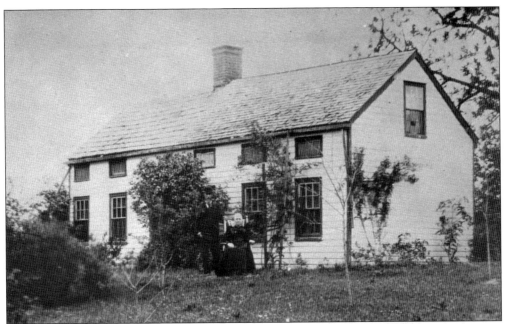

Located on the north side of Middle Country Road, near South Washington Avenue, this was the home of Reeves and Phoebe Howell, who are probably the couple in the photograph. After their deaths, the house went to their daughter Phoebe Ann Howell Bertram Ingraham, whose husband, Charles Bertram, the father of her two sons, Charles and John, died in 1871. In 1884, Phoebe married John Ingraham. Upon her death in 1926, the property passed to Charles Bertram.

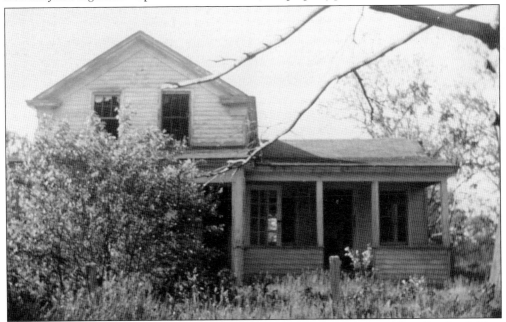

Located on the north side of Middle Country Road, west of Patchogue-Mount Sinai Road in Selden, this was the farmhouse of Samuel Mott, his wife, Mustifivia, and their five children. Listed in a 1901 *Port Jefferson Echo* article as one of the market growers of Selden, Mott, who was known for producing prize watermelons, owned land on both sides of Middle Country Road.

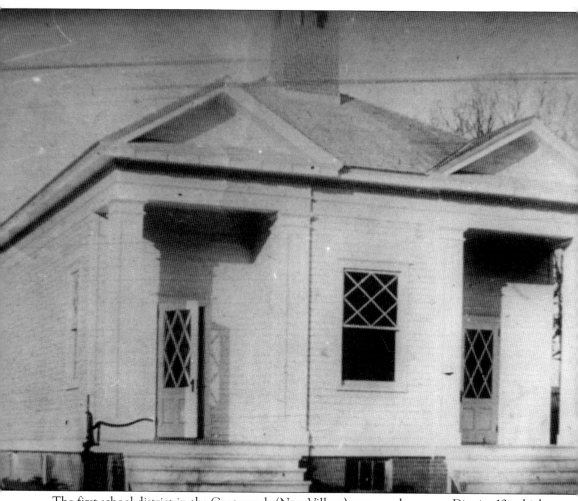

The first school district in the Centereach (New Village) area was known as District 12, which was created on November 13, 1813, when the Town of Brookhaven was authorized to break up the town into school districts. While the location of the first schoolhouse is unknown, the second schoolhouse was built in 1860 about 150 feet east of Rustic Road. The school district purchased the land for $75 and built the one-room schoolhouse, which had outdoor plumbing, for $400. In 1872, the school had 15 students, and the teacher was paid $300 per year. In 1914, a third schoolhouse was built in Centereach by contractor and local resident Scudder Smith. In 1929, the school was expanded and boasted three rooms to accommodate first through eighth grades. By 1931, there were 62 students and two teachers at the Centereach School. The third school was burned by order of the school board on November 24, 1968.

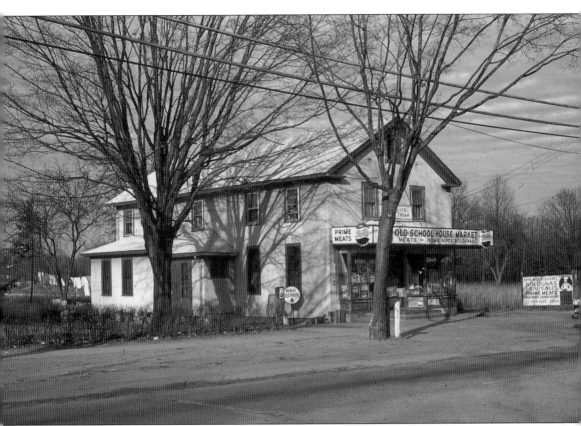

When New Village residents decided they wanted their own post office, they found there was another New Village in New York, and they would have to change the town's name. New Village residents Francis Craft, Arthur Murray, and Frederick and Everett Emery met to choose one. At Craft's suggestion, the name Centereach was chosen, as the hamlet was in the center of the island from all four compass points. On February 17, 1916, Everett Emery was appointed postmaster in the community to be known as Centereach. He used some of the lumber from the old New Village schoolhouse in his store and post office located on the north side of Middle Country Road approximately 100 feet east of Crown Acres Road. In 1923, Charles Ulrich took over the Schoolhouse Market and was appointed Centereach postmaster.

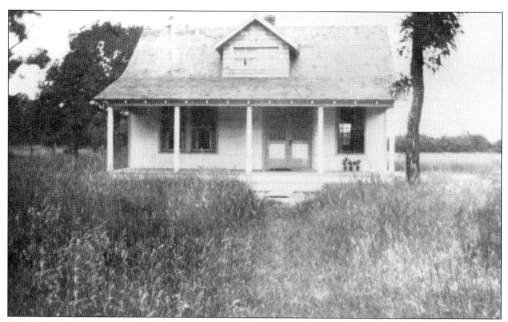

On October 26, 1924, Harold Murray, at age 31, married Laura Esther Smith of Port Jefferson. According to an article in the *Port Jefferson Echo*, after a motor trip in New England, the couple would occupy "their splendidly furnished bungalow." Located on Middle Country Road and the east side of Hammond Lane, this bungalow would, in later years, become the site of the Knotty Pine Tavern. (Courtesy of Barbara Russell.)

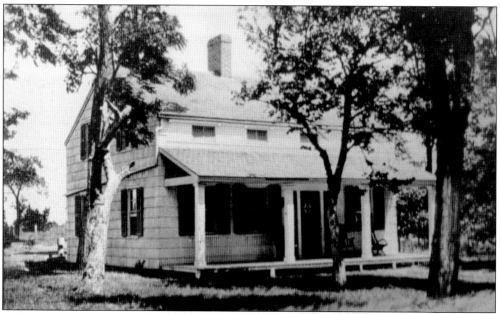

Located on Middle Country Road in Selden near the Duffield and Dare families, this cottage appears to have been the summer home of Elizabeth Smeltzer and her five sons, while her husband, John, a minister, remained in Brooklyn. In 1916, he officiated at the marriage of their son Royal to Maybelle Duffield. By 1930, John retired, and both he and Elizabeth are listed as residents of Selden.

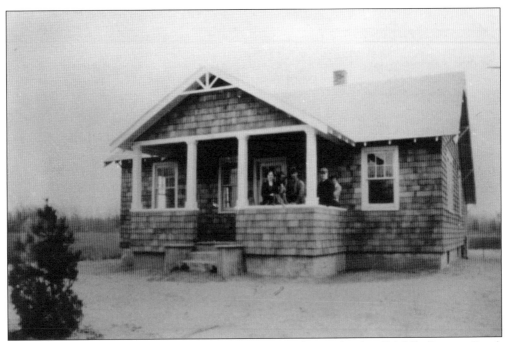

The home of Leslie and Amelia Duffield was located on the south side of Middle Country Road, approximately 100 to 150 feet east of Horseblock Road in Centereach. Here, four family members pose with their dog on the porch. (Courtesy of Barbara Russell.)

Amelia Duffield sits proudly behind the wheel of the family car in August 1924. The location is unidentified, but a wooden building is under construction beneath the pines on this hot summer day. (Courtesy of Barbara Russell.)

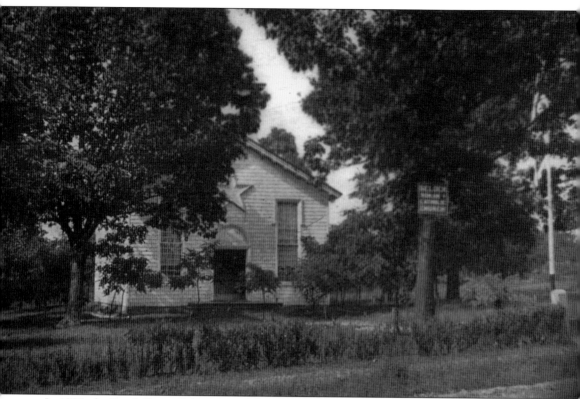

In 1906, the *Port Jefferson Echo* reported that the Catholic church of Selden, which in days gone by had served as a Presbyterian church, had been moved from its location on the south side of Middle Country Road to the property of J.F. Byrne on Selden Hill. In the July 21 edition of the paper, an open invitation was issued to friends and neighbors of all denominations to attend the opening mass, rain or shine, at 11:00 a.m. on the following morning. Under the leadership of Father Kimball, the church continued to flourish and, on the occasion of its eighth anniversary, in 1914, the celebratory mass was attended by 75 people and "all received a most hearty welcome from J.F. Byrne and Father Kimball."

Prior to 1927, the first Congregational church was often referred to by its parishioners as "the Lord's Barn" because of its square and unembellished structure. In 1927, however, dignity was enhanced when George Gould and family donated a bell and the church members provided a belfry to house it.

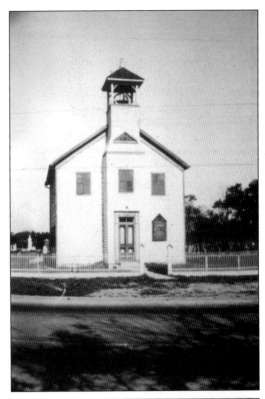

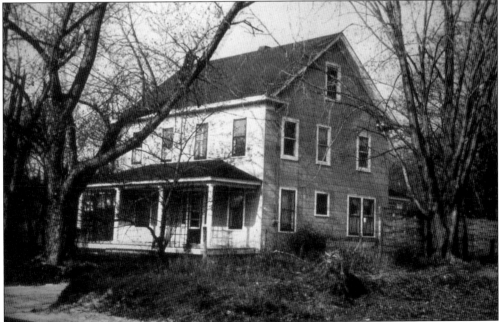

Before his retirement in 1886, Rev. Otis Holmes donated land to the congregation for a parsonage. The church members raised the money, and the parsonage was built. In 1913, it was destroyed by fire. The congregation again raised money to build the pastor's home. A year later, a new parsonage stood on Hawkins Avenue, 200 feet south of Middle Country Road.

The junction of Boyle and Middle Country Roads in Selden was the setting for this early 1940s winter view of the homestead of Wendell Shipman Still and his wife, Pauline Dare Still, daughter of Samuel Dare, and their daughters, Maybelle and Lucille. After receiving an honorable discharge from the US Navy in 1919, Still returned to Long Island and purchased a truck farm in Selden. Wendell was a very civic-minded citizen and a member of the American Legion, the Selden Volunteer Fire Department, and the Port Jefferson Yacht Club. He also served as chairman of the board of trustees for the Selden Public School District. Pauline was a teacher in both the Selden and Centereach schools for 12 years.

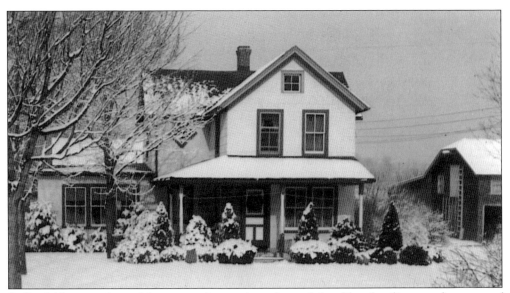

Still, a lifelong resident of the area and a member of one of the oldest families, was the owner of Wendell Still Enterprises. On his truck farm, Still grew vegetables and raised poultry as a source of income. In the 1930s, he began concentrating on broilers. By the 1940s, his poultry plant had the capacity to raise 250,000 broilers per year. He also became involved in the fuel industry, later becoming a wholesale gasoline distributor and retailer of fuel oil and kerosene. Still would go on to be a successful businessman who marketed various products, including different types of feed and commercial fertilizer.

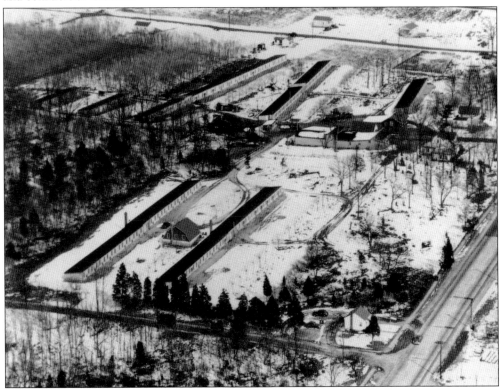

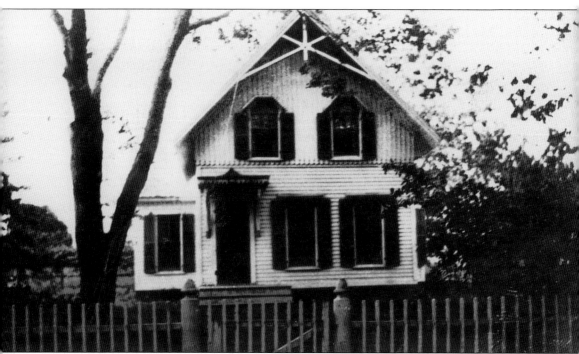

Located on the south side of Middle Country Road, opposite and west of Wood Road, this was the home of William and Sarah Williams Wortley and their children, Robert and Dorothy. Originally, the home belonged to the Gould family. When William Wortley opened his Texaco gas station in 1931, the Wortley family was likely already living here. Active in community affairs, Wortley was elected Centereach fire chief in 1937. It was in his garage, in 1933, that the first planning session for the new Centereach Fire Department was held. His filling station was also where the fire department stored its first truck while it waited for the fire department building to be completed.

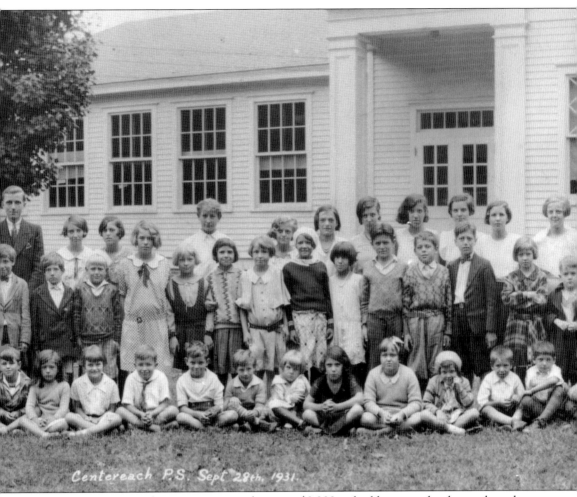

Centereach P.S. Sept 28th. 1931.

In 1912, the Centereach community voted to raise $3,000 to build a new school to replace the 1860 building that had been used for over 50 years. The contract to construct the school was awarded to lowest bidder Scudder Smith, a community resident. When the school opened its doors on September 11, 1914, Ella M. Fealy was the teacher. In 1929, due to an increase in the school population, a combination classroom-auditorium and new coatrooms were added. John Pearl, who had been school principal as well as a teacher for all eight grades, was joined that year by Damietta Kellogg as the first teacher in the new room. The old school was dismantled and sold to Everett Emery. As the school only offered up to eighth grade, students had to go to Smithtown to attend high school.

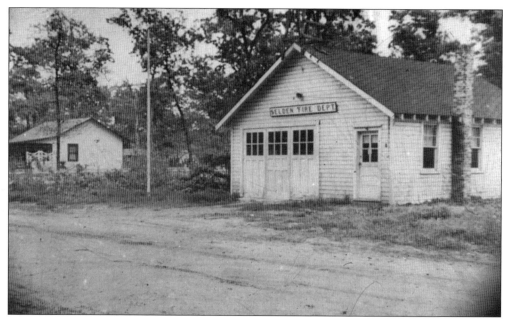

The first firehouse in Selden was on Middle Country Road east of Evergreen Avenue in an old barn owned by Nicholas Aylward. Operating funds for the department were raised from neighbors' contributions, summer fairs, and collecting loose change from passing motorists on large blankets in the middle of intersections in town. (Courtesy of Barbara Russell.)

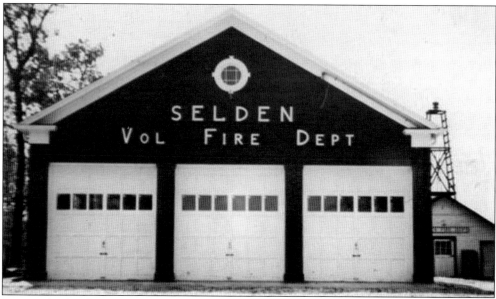

During the first half of the 20th century, Selden witnessed a population growth from just 100 to over 1,200 residents, reaching 3,000 during the summer months. It was this growth of Selden that created a demand for a larger fire department, and a new firehouse was built in 1943. The original firehouse was moved to the rear of the new building and can be seen at the right of this photograph. In 1949, the Selden Fire District was officially formed, allowing it to receive New York State tax support. (Courtesy of the Ida and James Harrington Collection.)

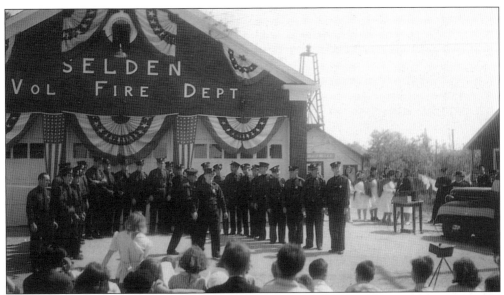

On Sunday, May 30, 1943, the Selden Fire Department held a dedication for its newly built firehouse. It was a full day of activities, games, and speakers. The affair started off with Chief William Haspel Jr. giving the welcome address, which was followed by several notable community members speaking about the growth and prosperity that Selden had seen over the past years. (Courtesy of the Ida and James Harrington Collection.)

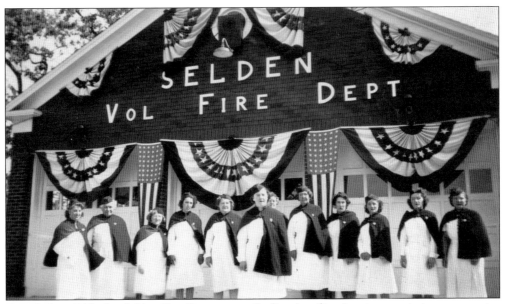

Founded in 1932, the Selden Fire Department Ladies Auxiliary's primary mission was to give assistance as needed or requested by the Selden Fire Department and participate in yearly community events and fundraisers. The group raised $100 for the firehouse dedication in 1943 and was praised by several speakers, particularly Brookhaven supervisor Edgar A. Sharp, who commented on the ladies' work and their fine-looking turnout. (Courtesy of the Ida and James Harrington Collection.)

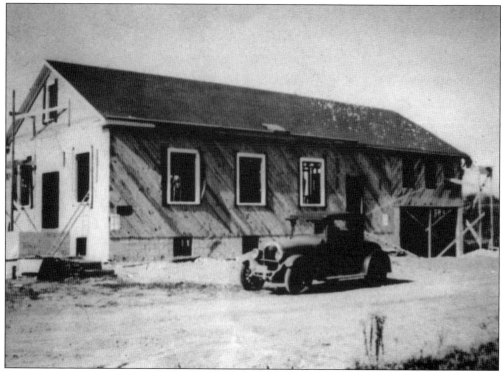

Due to the prevalence of forest fires in the largely wooded area of Centereach, a meeting held at the New Village Schoolhouse in March 1933 discussed the need for a firefighting force. The Centereach Fire Department was formed, and Arthur Murray was chosen as the first fire chief. Directed by a local contractor, the first firehouse was constructed on the corner of Washington and Elinor Streets.

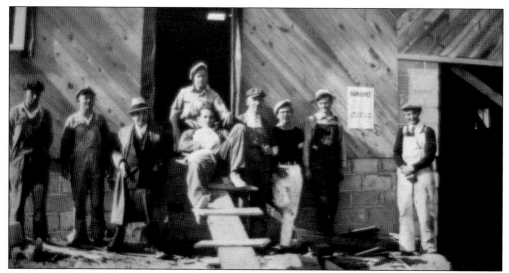

In the depths of the Great Depression, a local volunteer construction crew built the new firehouse. Crew members pictured here on November 3, 1933, are, from left to right, R. Everett Bowers, Louis Giles, Mr. Silverman, Elbert Burr, Terry Burr, Harry Duffield, Pete Scieden Schwartz, Ray Burr, and William Watson.

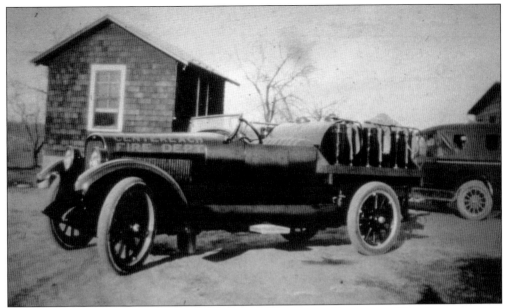

The first fire truck for the Centereach Fire Department, pictured here, was a Chandler automobile chassis donated by Teddy Ferro on which the firemen mounted a 200-gallon water tank. Until the firehouse was completed, the truck was stored at volunteer fireman William Wortley's gas station and garage on Middle Country Road.

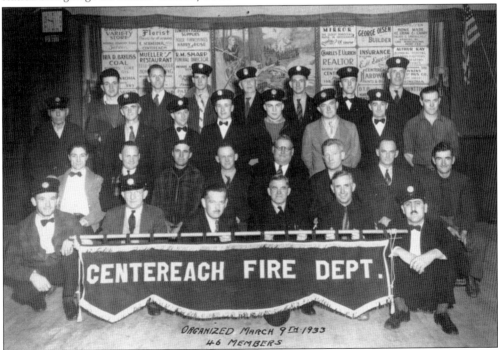

Against a background of posters advertising local businesses Mueller's Restaurant, Charles Ulrich Real Estate, Everett Emery's Hardware Store, and builder George Olsen, 29 of the original 46 members of the Centereach Fire Department pose in this photograph, proudly displaying the new Centereach Fire Department banner.

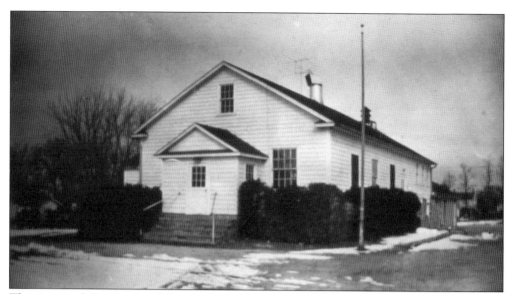

This image of the completed first firehouse, a modest wooden building, was taken when the hamlet of Centereach had only 628 residences and one fire truck. It served the community well until 1977 when a new firehouse of 43,000 square feet was built to replace it.

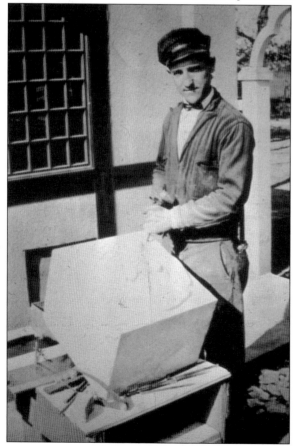

Over 80 years have passed since the completion of the first Centereach firehouse. While the headquarters are still on South Washington Avenue, two new fire stations have been added. Pictured here is William Tobin, a mason, as he carves the inscription for the cornerstone to be placed at the dedication of the first firehouse.

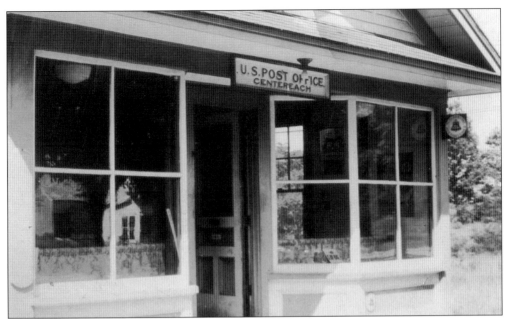

Located on the north side of Middle Country Road between Hammond Lane and Crown Acres Road, Centereach's first solely dedicated post office building is pictured above. Irma Emery, daughter of first Centereach postmaster Everett Emery, was postmaster from 1930 to 1944, followed by Anna Heron and Adele Groben. While a bare light illuminates the post office entrance, a Bell Telephone sign advertises the pay phone located inside the building. A Red Cross poster can be seen through the window on the right, most likely publicizing a public health concern. Two small wooden buildings are visible in the reflection of the windows on the left. In the image below, Charles Benson, mail carrier for Lake Ronkonkoma, Lake Grove, and Centereach, is delivering the twice-a-day mail, accompanied by his dog Pete. Pete trained himself to ride on the sideboard of the mail truck and often received treats from mail recipients.

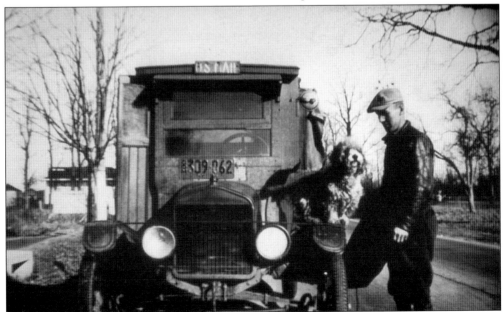

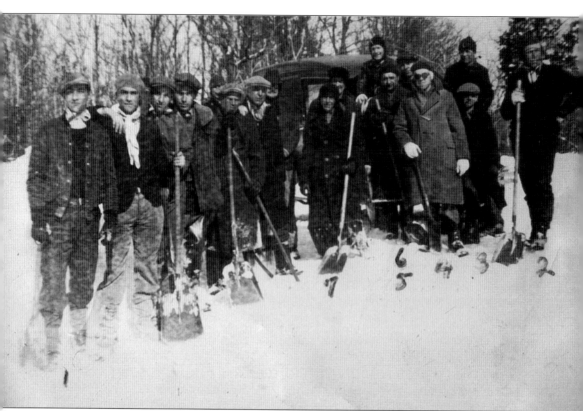

Besides the 1888 storm, the blizzard of 1934 is remembered as one of the worst snowstorms this area has ever experienced. It snowed all day Monday and Tuesday, February 19 and 20, tying up all inter-village transportation, with some villages being isolated and suffering food shortages. Drifts from 5 to 10 feet high were reported, and many people stranded in stalled cars were rescued by volunteer groups. In many suburban central offices on Long Island and other places, the volume of calls ranged from 2 to 2.5 times the normal number. In this photograph, 17 Centereach men stand holding their shovels as they assist with snow removal. Among those identifiable are Pete Anderson, R. Stegemann, Peter Smith, Al Urlander, Chas Lambau, and Frank Urban. Centereach mail carrier Charles Benson is indicated in the photograph by the number 6 below him; no one else is specifically identified. (Courtesy of Barbara Russell.)

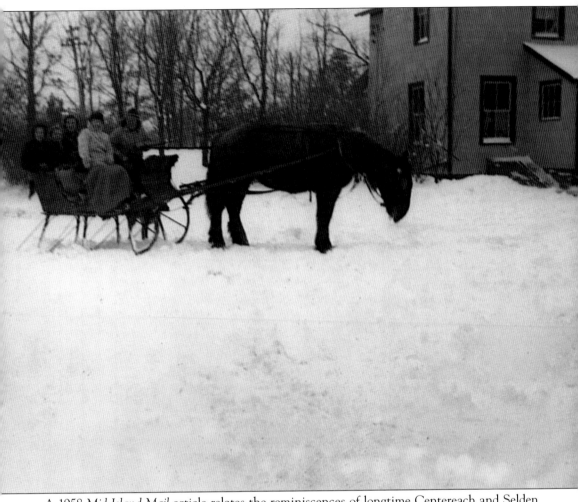

A 1958 *Mid-Island Mail* article relates the reminiscences of longtime Centereach and Selden residents recalling the 1934 blizzard. Snowdrifts 10 to 15 feet high and inadequate snow clearing methods made transportation virtually impossible. Many days passed before there were more than four scholars in attendance out of the 18 children enrolled in the one-room schoolhouse. Arthur Murray recalled his father and his uncle Scudder Smith discussing hooking up Smith's horse to the Murrays' bobsled to transport their four children and the teacher to the school. Longtime residents Alice Rogers and Nancy Murray had to abandon their horse and buggy in the middle of a snowbank and trudge through hazardous drifts before finding shelter at a neighbor's home. Many local residents resorted to using clotheslines to transport food items from house to house. (Courtesy of Barbara Russell.)

Alvin Smith, special constable of the town of Brookhaven and known to all as "Smitty the Cop," patrolled his territory, which ran from the Smithtown border to the Riverhead line. During the blizzard of 1934, he needed skis to access residents and homes snowbound from the 30 inches of snow that had blanketed the area.

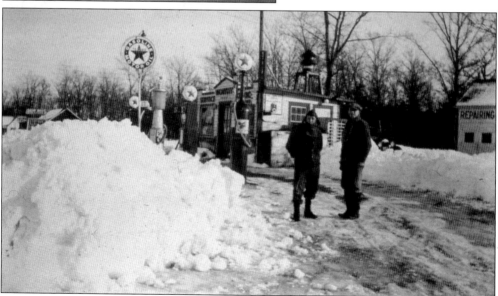

Four days after the onset of the memorable 1934 blizzard, this photograph was taken of local residents Maurice Anderson and John Pearl, Centereach teacher, at William Wortley's gas station. Located on the south side of Middle Country Road and a quarter of a mile east of Stony Brook Road, Wortley's Texaco station started operations in 1931.

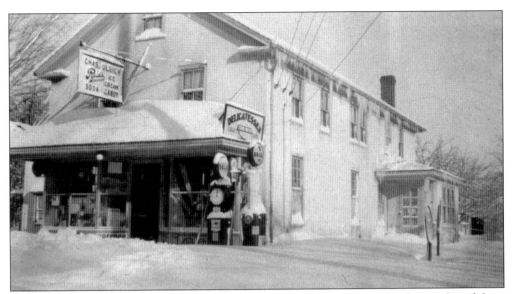

A winter scene of Charles Ulrich's general store, the Schoolhouse Market he purchased from Everett Emery, shows icicles hanging from snowy eaves. The store carried a great variety of merchandise—everything from ice cream, candy, deli sandwiches, and soda, to gasoline and skis. Ulrich, originally from Middle Village in Queens, and his wife, Christobel Steuerholtz, were active members of the local community. A charter member of the Centereach Fire Department, Ulrich also served as a director of the National Bank Company of Ronkonkoma while managing his own real estate company and operating the store.

In this photograph, baled hay is being loaded onto a conveyor by Roy Overton. Both a tractor and horse-drawn plow can be seen, indicating a transition from horse-drawn vehicles to mechanized farming. This scene most likely took place in the 1930s.

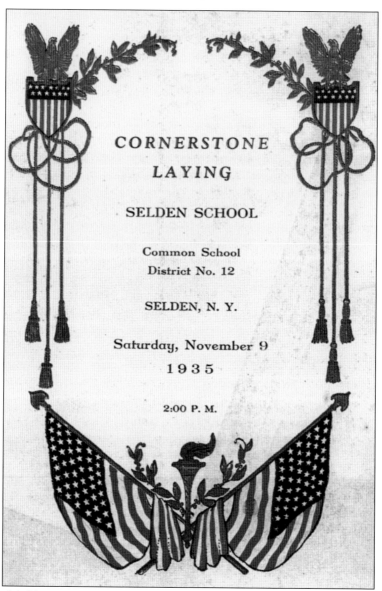

CORNERSTONE
LAYING

SELDEN SCHOOL

Common School
District No. 12

SELDEN, N. Y.

Saturday, November 9
1935

2:00 P. M.

Selden schoolchildren sang "America" and "The Star-Spangled Banner" during the ceremony on November 9, 1935, when the cornerstone was laid for the soon-to-be-built new Selden School. District board of education president Wendell Still spoke, along with board members Anna Aylward and Rosetta Duke, civic association president Clarence Keefer, community club president J. Logan Dare, newly elected fire chief Nicholas Aylward, district superintendent Roscoe Craft, and others. Sealed within the cornerstone was a copper box containing current local newspapers (the *Patchogue Advance*, the *Argus*, and the *Mid-Island Mail*), the year's school census, a copy of the day's program, a 1935-minted dime and penny, and an 1885 almanac.

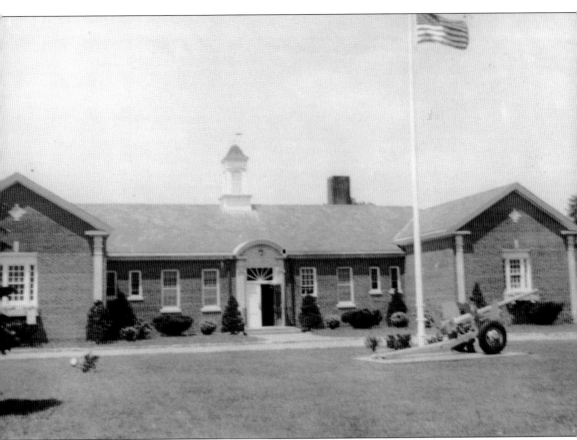

The Selden Elementary School, built in 1936, replaced the one-room schoolhouse. Located on Middle Country Road east of Bicycle Path on two acres of land purchased from Logan Dare for $1,000 per acre, the new school contained three classrooms, a principal's office, a nurse's room, boys' and girls' washrooms, a cellar with an oil-burning heating system, a well house, and a 1,500-gallon oil tank. The cannon in front of the building was US Army surplus purchased after World War II with nickels and dimes saved by the schoolchildren of Selden. The plaque in front honors the Selden servicemen of World War II. The building was renovated in 1948, and was given to the library by the school district in 1984. That year, it became the Middle Country Public Library Cultural Center. Extensively renovated again in 2003 with a 10,000-square-foot extension, it is now known as the Middle Country Public Library Selden.

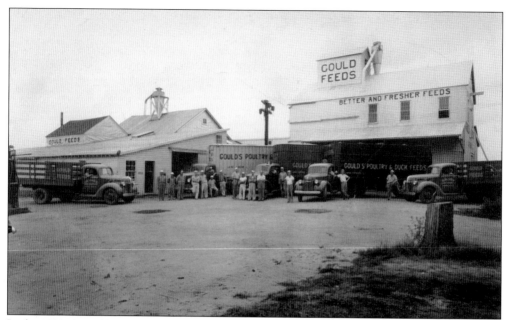

In the 1930s, Harold Gould established Gould Feeds. Located on the west side of Hawkins Avenue and north of Moriches Road in Lake Grove, the company supplied feed for many of the Long Island duck farms. In 1945, Gould's partner, Lawrence Cohen, purchased Gould's shares in the company. After most of the buildings were destroyed by fire, the property was put up for sale. (Courtesy of Joyce Bogin and Sidney Williams.)

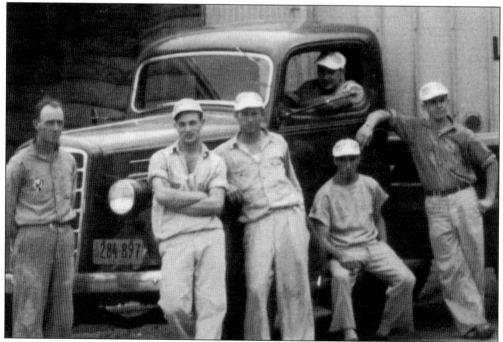

Gould Feeds became a major employer in Suffolk County, with over 100 people on its payroll. This photograph of six Gould Feeds employees includes local nonagenarian Sidney Williams at the wheel of the delivery truck. (Courtesy of Joyce Bogin and Sidney Williams.)

The Gould property has played an important role in the history of Lake Grove. Pictured here in the late 19th or early 20th century is a couple fishing at Gould's Pond, a kettle lake formed by a glacier. Its shores once held two icehouses used to store ice cut from the pond surface during the winter.

Built on the Gould property, the house is listed in the 1873 F.W. Beers Atlas of Long Island with the name J.B. Gould as property owner. With the incorporation of Lake Grove in 1968, the village purchased the property and house from Lawrence and Rita Cohen. At that time, the James B. Gould house became the first Lake Grove Village Hall.

In 1918, in an effort to prevent the spread of forest fires, the New York Conservation Commission began erecting fire observation towers. Telescope Hill, Brookhaven's highest elevation at 334 feet above sea level, was chosen as the site for the construction of a 60-foot Aerometer LS 340 tower with a cab on top. In operation from 1919 to 1959, the fire observation station was located at the end of Tower Hill Road on the border of Farmingville and Selden. At the beginning of World War II, an additional cab was added to the structure for the observers to spot forest fires. Civil defense observers used the original cab to search for German U-boats in the waters around Long Island. They have been credited with spotting U-boats on three separate occasions, one of which resulted in the capture of an enemy submarine.

Pictured in the Bald Hill Fire Tower, Clarence "Cad" Dare, a fire ranger for over 32 years, was in charge of directing forest fire management in the woodlands of Suffolk County and the town of Oyster Bay. A lifelong Selden resident, he also served as Brookhaven town highway superintendent from 1915 until 1920, when he resigned the post to accept the fire ranger position. A colorful firefighter, Dare directed every major forest fire in both counties. In April 1952, at age 70, he was credited with working for over two days straight extinguishing a forest fire that burned from Holstville to Selden and required the use of 90 percent of Brookhaven's fire apparatus to fight. And, as a *Patchogue Advance* article reported, Dare was "eating smoke with men half his age keeping at his fingertips a knowledge of what was going on over hundreds of acres of burning trees and scrubs." Dare died of a heart attack later that year.

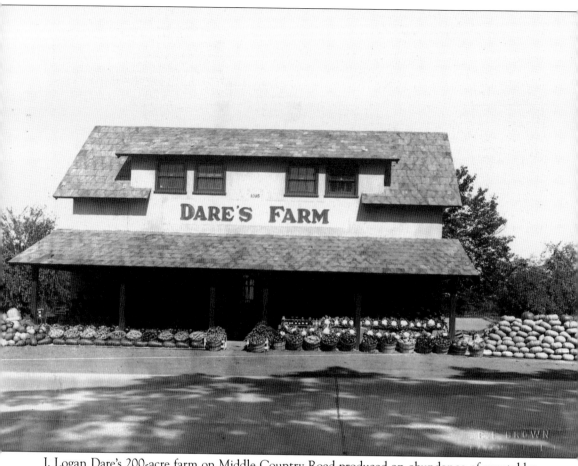

J. Logan Dare's 200-acre farm on Middle Country Road produced an abundance of vegetables and fruits for the hotels, stores, and roadside stands that dotted the Long Island landscape. Dare, son of Civil War veteran Samuel Dare and brother of forest ranger Clarence Dare, was active in civic and community affairs. In 1935, while the nation was enduring the depths of the Great Depression, he loaned 15 acres of land and a building to be refitted as a cannery for a government agency. The estimated 50,000 cans of beans and tomatoes and 15,000 bushels of root vegetables that would be produced were scheduled for distribution to needy families during the upcoming winter. A prizewinning grower, Dare won numerous yearly awards for his fruits and vegetables at the Nassau County Fair at Mineola as well as at the Suffolk County Fair at Riverhead.

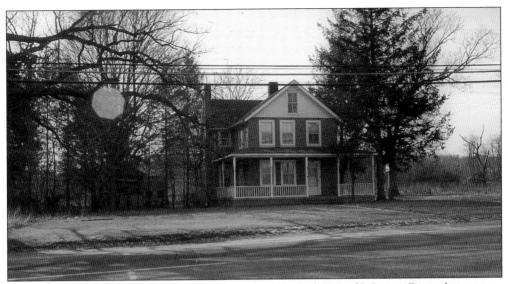

This two-story house, pictured here around 1930, was the home of J. Logan Dare, the younger son of Samuel and Henrietta Dare, his wife, Arabella, and their daughter, Virginia. In addition to his prize fruits and vegetables winning many awards at county fairs, in 1935, Dare's team of farm horses won first prize at the Suffolk County Fair in Riverhead. Dare also served as president of the Selden Community Club, director of the Suffolk County Farm Bureau, and vice president of the Central Brookhaven Republican Club. In later years, the house became the parsonage for the Presbyterian church. Located on the north side of Middle Country Road in Selden, the house below was the home of Samuel and Henrietta Dare. After Samuel's death in 1913, Henrietta continued to live here and be active in church and community affairs. At her death in 1937 at 86 years of age, she had lived in Selden for 66 years. (Both, courtesy of Barbara Russell.)

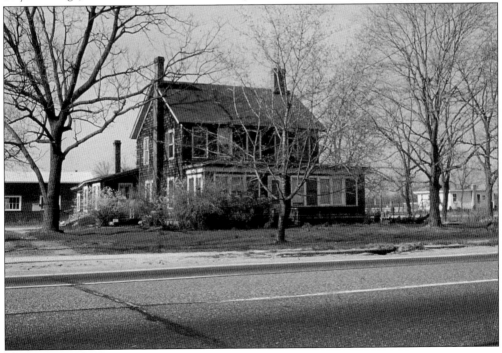

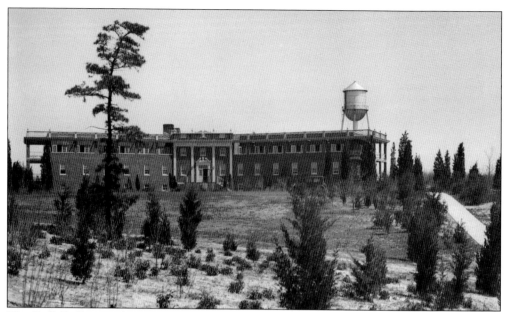

The Suffolk County Sanatorium was opened in 1916 in what was then Holtsville. The first superintendent of the sanatorium was Dr. Edwin P. Kolb. Under his direction, the death rate from tuberculosis declined from 105 per 100,000 to 20 per 100,000. Wings were added to the main building in 1920 and 1922, and two more buildings, the Marshall (above) and Ross (below), were WPA projects constructed in 1934. The Ross Building was for adults and named after Dr. William Hugh Ross, who was a proponent of the construction of a tuberculosis sanatorium. The Marshall Building was for children and named after Dr. Joseph H. Marshall, the chair of the Suffolk County Medical Association. Despite the fact that the sanatorium had a capacity of 160–170, the patient population was less than 100 during World War II due to the lack of help. As a result, the Marshall Building was closed in 1943. (Both, courtesy of Ray Welch.)

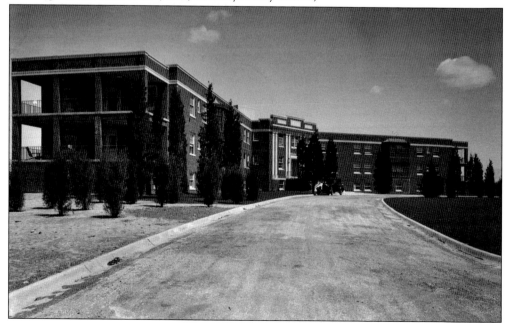

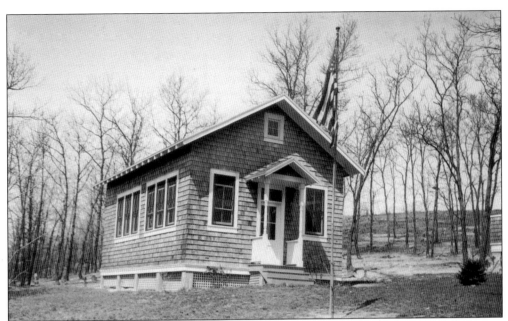

Operated for child patients of the sanatorium, this small school opened in 1923 as Suffolk County District No. 4 of Brookhaven Town. Teacher Fannie Curtis instructed the 22 students. The school received many donations, including playground equipment such as coaster slides, swings, and seesaws. Dr. Edwin P. Kolb, serving as a one-man board, directed the school finances. The school, like the Marshall Building, was closed in 1943 and officially dropped from the rolls of the school district. The structure was demolished in 1968. (Courtesy of Ray Welch.)

During World War II, a small cupola-like building, pictured here, was built on the roof of the Marshall Building as an aircraft-spotting station. Its purpose was to house spotters who watched the skies for enemy aircraft. The gentleman in the dark suit is the superintendent of the sanatorium, Dr. Edwin P. Kolb. On his left arm is a civil defense armband. A compass rose is also visible in front of the woman pointing her arm toward the sky. (Courtesy of Ray Welch.)

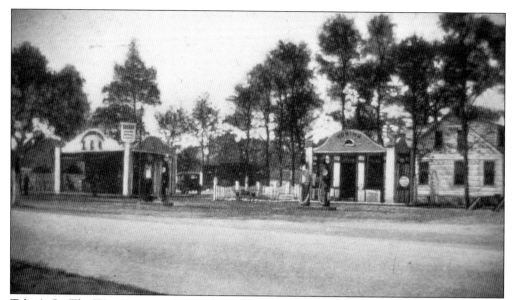

Tobin's On-The-Way Rest, a rest stop along the highway for travelers of Middle Country Road, served refreshments and provided Sunoco gas, Goodrich tires, and auto parts. Once a dusty, dirt-covered, one-lane road, Middle Country Road is shown here in the early 1930s in its newly paved concrete state.

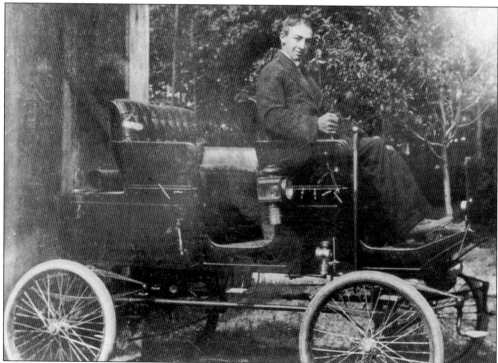

Pictured here is Percy L. Overton, a Lake Grove resident, driving a 1916 Maxwell touring car in Port Jefferson. In 1920, Percy was employed as a chauffeur. In 1925, the Maxwell Motor Company became part of the Chrysler Corporation. (Courtesy of Joyce Bogin and Sidney Williams.)

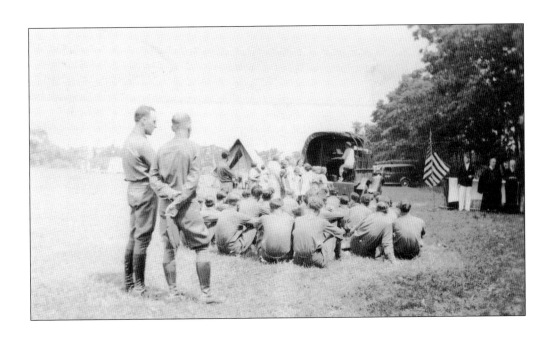

Looking at the section of Middle Country Road and McGaw Avenue now, it is hard to imagine that during World War I and part of World War II, this area was an empty field covered with Army tents and uniformed men preparing to go to war. Religious services and training maneuvers were conducted here during that time. The owner of the land, Martin Metzner, leased his property to the US government for this purpose. Hand-dug wells, which were eight inches in diameter, were used to provide water to the troops. Longtime resident Sidney Williams recounts that these wells were still in existence and found years later behind and just north of his house in that area. (Both, courtesy of Joyce Bogin and Sidney Williams.)

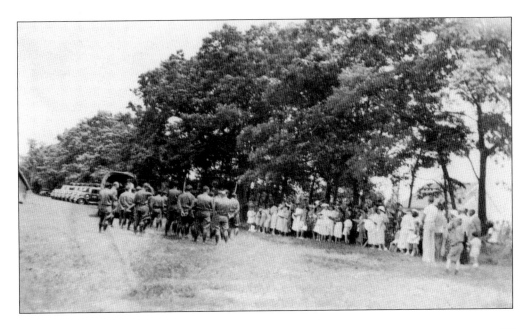

MIDDLE COUNTRY PUBLIC LIBRARY CENTRAL DIST. No. 11

The Nature's Garden Clubhouse, pictured here, served different functions during its lifetime. In the early 1930s, when small vegetable and fruit farms still lined Middle Country Road, O.L. Schwenke Land & Investment Company purchased a large tract of land and began selling housing lots to buyers from New York City for as little as $19 for a quarter-acre lot. Enticed by advertisements that boasted paradise garden plots, vacation camps, or retreats set in "beautiful high-wooded or open-level sections," buyers came by busloads to this sales office of the development called Nature's Gardens. This development was the first of many that would gradually transform Selden into the 20,000-strong suburban community it is today. The sales office became the community clubhouse housing religious services, civic groups, and community functions. It housed the Selden branch of the Middle Country Public Library until 1984, when the library moved to its current site in the renovated Selden School.

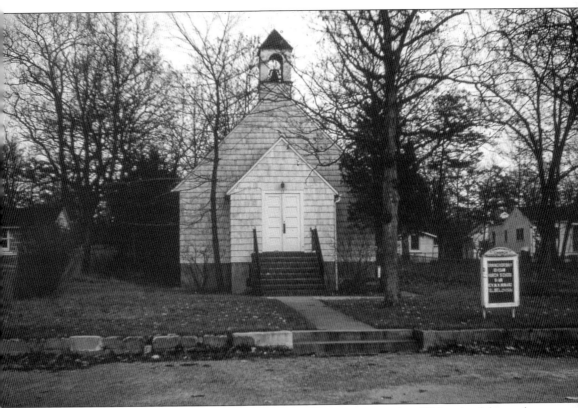

The Selden Community Presbyterian Church, pictured here, was erected in 1934 on land donated to the church by the O.L. Schwenke Land & Investment Company and located on South Evergreen Drive in Selden. Before the church opened, Sunday afternoon services were held in the homes of residents, most of whom had just purchased land in the Nature Gardens sections of Selden. Material for the building was donated by Loper Bros. Lumber Company of Port Jefferson and the Island Coal and Lumber Company of Medford. It was completed by Thanksgiving 1934 and dedicated as the Nature's Gardens Community Church on December 30, 1934. The steeple and bell were added around 1937, with the pews a few years later. An organ was installed in 1948, and the church bought the former Logan Dare homestead for its manse in the early 1950s. In the 1940s, during the pastorate of the Rev. Frederick Williams, the Long Island Presbytery changed the status of the church from a mission under the Port Jefferson Presbyterian Church to a fully organized church.

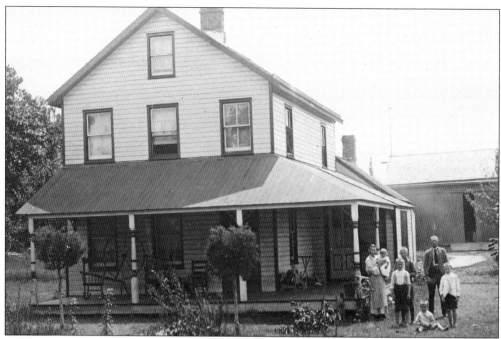

Frank Overton, son of L. Irving and Matilda Overton, is pictured here with his wife, Martha, and children Percy, Howard, Ernest, and Edwin at their home and farm on the north side of Middle Country Road east of Dietz Avenue in Lake Grove. Their daughter Alice, who was born in 1907, is absent from the photograph. Frank, in addition to managing the farm, was also a mail carrier and hackman.

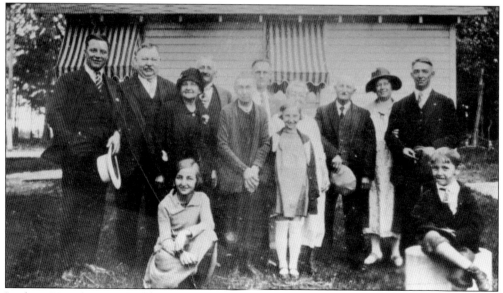

In this 1930s photograph, Charles Fisher and Mrs. Koehler have gathered with members of the Overton family, including Frank L. and Martha, Fred, Edgar, Belle, Howard F., Frieda, Alice, Adeline, Martha, and Irving Howard, on the side of Frank Overton's flower shop and general merchandise store located on the south side of Middle Country Road in Lake Grove. (Courtesy of Barbara Russell.)

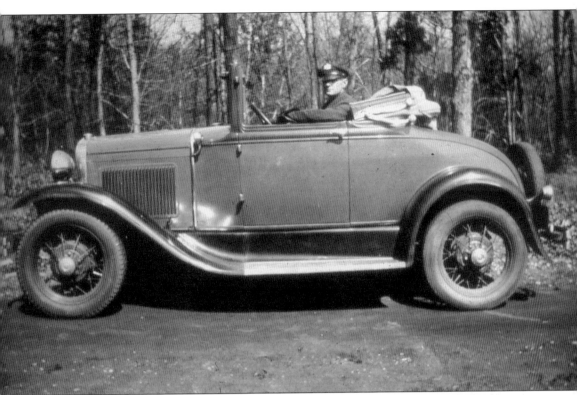

In this photograph, special constable Alvin Smith is pictured seated in his 1930 Ford police car, covering his jurisdiction, which included the Centereach, Lake Grove, and Selden communities. In 1989, Alvin's wife, Ethel G. Smith, presented a letter to the library's heritage collection in which she describes the evolution of the town police force. Initially, Alvin's duties called for him to be available 24 hours per day, seven days a week. As time passed, Alvin became acquainted with everyone in his territory on a first-name basis. By 1937, as the population increased, the force of special constables had grown to nine men, and it was decided to form a police force. By 1951, the force was legally made a department of the county, with 51 members. Alvin retired in 1960 after 30 years of service.

Located on the north side of Middle Country Road, east of Middle Country Road and Stony Brook Roads, this lovely house and farm, shown in this mid-20th century photograph, was known as the Wilkinson Home. Reported to have originally been the site of a tavern in the 19th century that was owned, at various times, by a L'Hommedieu, a Reeve, and a Tillotson, it came into the possession of the Wilkinson family in the late 1800s. Census records show that Josephine Wilkinson, a widow, is listed as head of household in 1900. By 1920, the home and poultry farm had passed down to son Frederick and his wife, Evelyn Coleman Wilkinson. In 1963, the residence was occupied by Fred's brother, Nelson. By 1981, the structure was demolished and a shopping center built on the site.

94

Four

POPULATION EXPANSION
1950–PRESENT

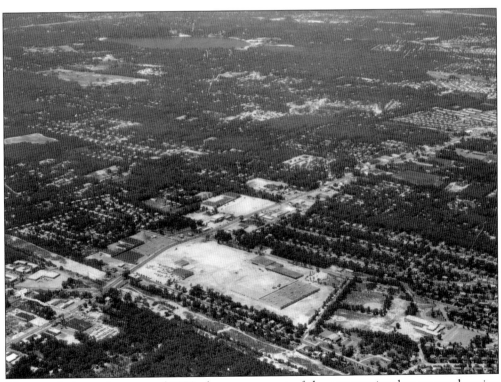

This aerial view, taken around 1970, shows a segment of the community that was undergoing change. While housing developments have proliferated, wooded plots still lie untouched. The visible stretch of Middle Country Road shows relatively few retail establishments and only moderate traffic.

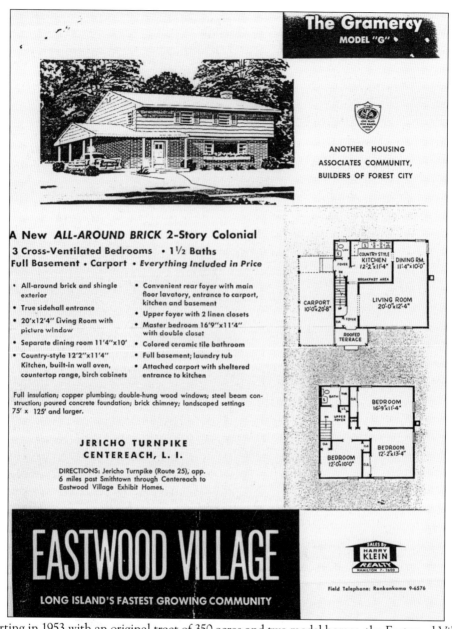

Starting in 1953 with an original tract of 350 acres and two model homes, the Eastwood Village project ballooned into an 800-acre community offering the largest display of exhibit dwellings on Long Island. Developer Bernard Krinsky reported that it was the first large-scale home project to be erected in Suffolk County. By 1958, there were over 1,250 occupied homes and a population of approximately 6,000 persons. Most of the buyers were first-time homeowners and over 45 percent were families with two or more children. There were 10 differently styled three-and four-bedroom homes ranging from $11,500 to $14,250 shown on Eastwood Boulevard and Middle Country Road in Centereach. The model shown here was the Gramercy home, featuring oak floors throughout, with the exception of the kitchen and bathrooms. In 1957, the American Institute of Architects selected one of the Eastwood Village models as a winner in the annual Homes for Better Living competition. (Courtesy of Gerry Toth.)

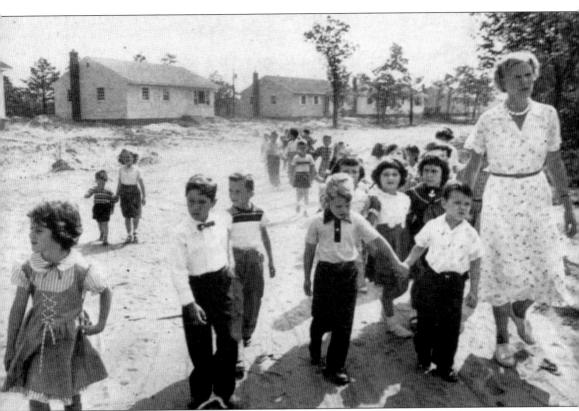

"Ten Little Schoolhouses in Centereach" is the headline of the May 12, 1955, *Newsday*. "Housing Projects Become Classrooms" titles a *Life* magazine article from September 1954. As population surged in the 1950s, three hundred Centereach elementary school students were attending classes in an old five-room schoolhouse, the stage of its auditorium, and the village firehouse. In 1954, a $900,000 new school bond issue was defeated, resulting in an acute classroom shortage crisis as an additional 135 new students were enrolled. In August, the school board contracted with local Eastwood Village builders to lease 10 one-room gas-heated model homes for three years for use as individual elementary schoolhouses. After that, the contractor could convert them into houses. The builder announced the men would "work around the clock—by floodlight at night" to complete the job. With the aid of community members and PTA volunteers serving refreshments, the classrooms were completed for the opening of school on September 8 of that year. (Courtesy of *Life*.)

Joseph Savino, who immigrated to the United States in 1881, is shown here on his farm on Moriches Road looking south toward Middle Country Road in the mid-20th century. At that time, Moriches Road was continuous from north of present Route 347 south through Middle Country Road. Today, the Savino farm property is part of the Smith Haven Mall.

This farmhouse, located on the northeast corner of Middle Country and Moriches Roads, is believed to have been the home of both the W.J. and Israel Hawkins families as well as the DeCico family. In 1930, census records show that Joseph and Angelina Savino and their three daughters, Louise, Loretta, and Frances lived here. The house, in existence since 1877, was demolished to make way for the Smith Haven Mall.

The Knotty Pine Tavern, formerly Carl's Tavern, opened in 1939. Located on Middle Country Road and owned and operated by Jack Morloth, it was the scene of many children's parties, dances, card parties, local political and social club meetings, and New Year's Eve parties for over four decades. For a time, it was known as the Pour Tavern. In 1992, it was renovated and became the home of Diamond Jewelers.

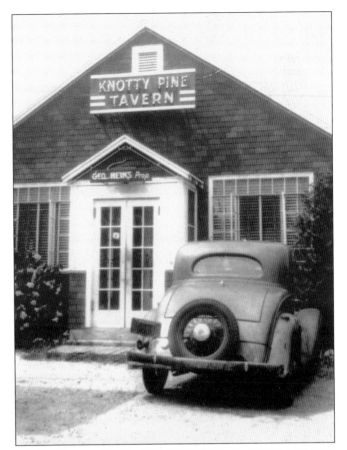

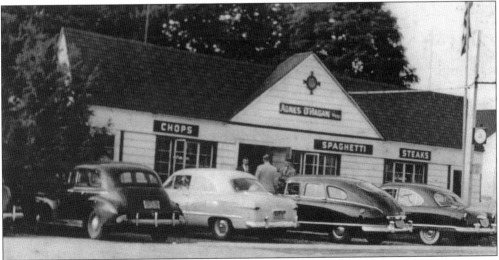

For over 40 years, Aggie's Steak House, located on Middle Country Road in Selden, was the local watering hole for area residents. It opened in 1927 and was owned and operated by Agnes O'Hagan. Saturday nights would find considerable crowds enjoying square dancing and other specialty dances with music provided by Aggie's Brown Jug Mountaineers. (Courtesy of the Agnes and James O'Hagan Collection.)

Founding members of the Centereach Chamber of Commerce greet the crowd in this 1962 photograph. The chamber was established in 1961 with a goal to make and keep the community a vibrant and thriving place to work, play, and live. Chamber members pictured include Michael Dundon, Leon E. Giuffreda, and Mary Giaquinto, among others.

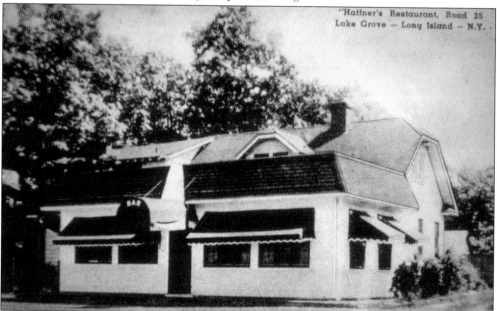

Located on the south side of Middle Country Road, west of Homestead Road, Haffner's was built by George Muller from 1939 to 1940. Operated by George and Ruth Haffner, the restaurant was the scene of many local gatherings, especially fire department dinners during the late 1940s, as reported by the *Patchogue Advance*.

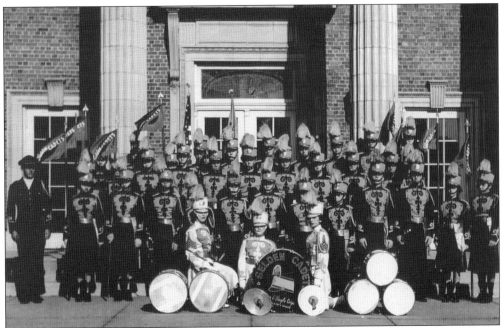

The Selden Cadets Drum and Bugle Corps has had a long history with Selden. It first started as the Selden Fire Department band in 1949, broke ties with the fire department in 1954, and formed the Selden Cadets Drum and Bugle Corps the same year. It was a rough start for the group. Families took out mortgages on their homes to buy instruments, every uniform was homemade, and money was raised by asking for donations in tin cans on Middle Country Road. In 1954, the band (above) had over 30 members between 14 and 21 years old. The group won over 10 national championships and marched in numerous parades during its time together, which ended in 1965 when it was disbanded. Below, the corps is seen marching on Middle Country Road during a parade in 1962. It still performs today as an alumni organization that tours locally and nationally. (Both, courtesy of the Selden Cadets Alumni Drum and Bugle Corps.)

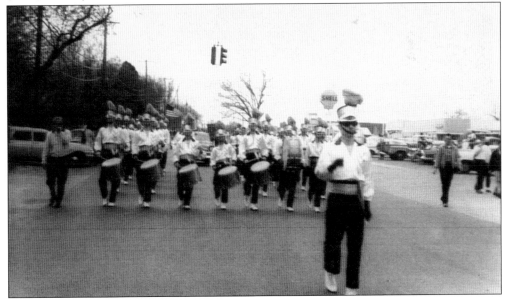

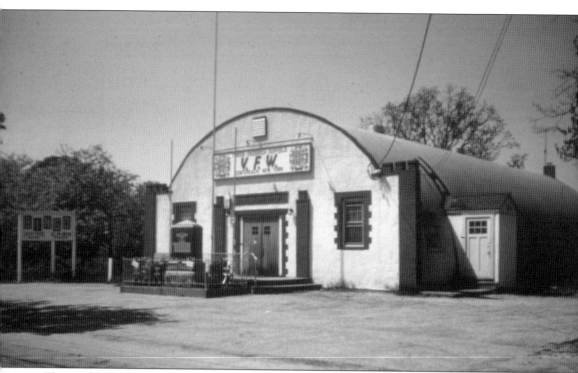

The Tordik-Diederich-Duffield Veterans of Foreign Wars Post No. 4927 was officially organized on November 24, 1945, and was named for three Centereach men who had lost their lives in the armed services during World War II. Located on the north side of Middle Country Road about 500 feet west of Rustic Road on property donated by the Murray family, the first headquarters was the Quonset hut shown here. In its first 25 years, the post formed many auxiliary service groups. One of them, the Red Baron Fife and Drum Corps, formed in 1967, consisted of a senior and junior band, made up of children of post and auxiliary members. This band won the Suffolk County Fife and Drum Championship and was the official band of the East Setauket Fire Department from 1967 to 1973. The new VFW Hall in Centereach opened in October 1970 on Horseblock Road. The old building was destroyed by fire on April 7, 1983, and the site became the home of Aboff's Paint and Wallcoverings.

The Bethel-Hobbs Community Farm, located between Stony Brook and Oxhead Roads, has a long history in the Centereach area. Originally belonging to James Hobbs, it is currently the last working farm in Centereach. In 1906, Hobbs came to New Village from Georgia and grew produce for local residents, eventually going from farmworker to farm owner. He purchased the 7.64-acre farm and operated one of the few African American–owned farms in Suffolk County. After James's death in 1929, his son Alfred took over. Upon Alfred's death, Hobbs Farm was left to the Bethel AME Church of Setauket. Due to legal complications, the property fell into disrepair. In 2007, the Friends of Hobbs Farm was formed to help restore the farm and property. The restoration process began in 2008 with the farmhouse and barn renovation and the start of a cooperative gardening project where the produce raised is donated to local food pantries. In 2009, Brookhaven closed on the purchase of development rights for Hobbs from the Bethel AME Church to ensure that Hobbs Farm remains forever farmland.

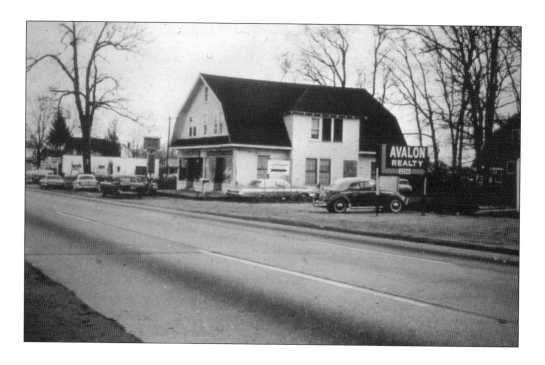

Located on the south side of Middle Country Road, east of Emery Lane, was Everett Emery's Hardware Store. After Charles Ulrich took over the Schoolhouse Market, Everett Emery opened the large hardware store pictured here. The photograph above, taken in 1963, shows a prominent sign advertising Avalon Realty at 2254 Middle Country Road. The photograph below, taken in 1965, shows the newly painted hardware store on a nearly deserted, rain-soaked Middle Country Road. Obviously, the sparse amount of traffic had not yet necessitated the use of traffic signals.

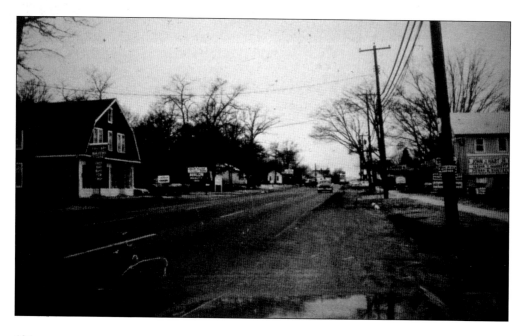

This photograph shows the charter members of the Selden Civic Association in 1952. The association began informally when residents who had moved to the countryside met together at one another's homes. At this time, Selden was home to very few year-round residents. To travel here, visitors drove many miles on a rough, two-lane, tree-lined road. When the summer residents left for the season, the locals entertained at family gatherings, picnics, potluck dinners, dances, card games, and chats around a potbellied stove. Over time, these gatherings moved to the Nature's Gardens Community Clubhouse and the Selden School. Discussion began with a goal of organizing a formal club so that the community members could be represented at town meetings and other civic activities. The position of civic association president was first held by Frank Gilberti. Charter members, many of whom are pictured here, included members of the following families: Panse, DeMarco, Henry, Hough, Smith, Simons, Hirsch, Savering, Hogan, Ille, Lott, Kistner, Timsries, Matteo, DiMartino, and Perioco, who were each honored at the 20th anniversary of the association in 1972.

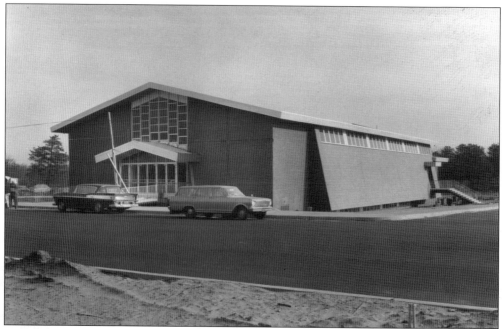

St. Margaret of Scotland officially became a parish on June 10, 1948. The first church, on the north side of Middle Country Road in Selden, served the parish for 17 years. In 1960, under the leadership of Fr. Sylvester McAvey and due to the increase in the Catholic population of Selden, the church moved to its new location on College Road.

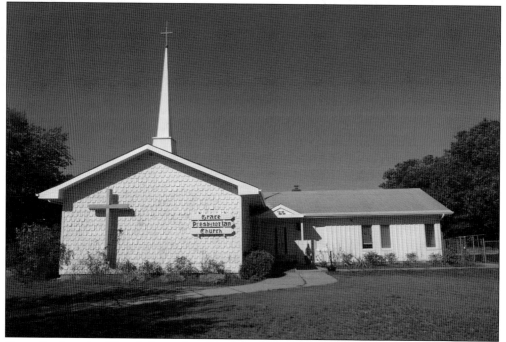

Grace Presbyterian Church, located on Hawkins Road in Selden, was a union of the Community Presbyterian Church of Selden and the Centereach Community Church. This union took place on January 1, 1964. The ground breaking of the present building took place on October 9, 1966.

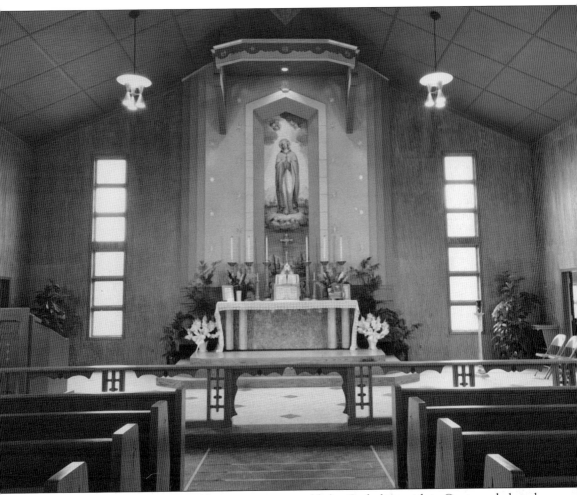

With $400, Fr. Francis Fitzgerald was sent out to establish a Catholic parish in Centereach, based on a letter sent to the archbishop by a local resident. On the July 10, 1955, Father Fitzgerald presided over the first Catholic mass in the VFW hall on Middle Country Road. The parish, named after a church from Father Fitzgerald's youth in Ireland, served approximately 1,000 families. In 1956, a building campaign raised $88,792 in just two weeks, and on May 9, 1957, a ground breaking was held for a new church. By September 1958, the building was completed and Assumption of the Blessed Virgin Mary Roman Catholic Church was dedicated by Bishop Molloy of Rockville Centre. In 1980, the parish, now with over 3,400 families, celebrated its silver anniversary jubilee. In June 2005, a 50th anniversary celebration took place.

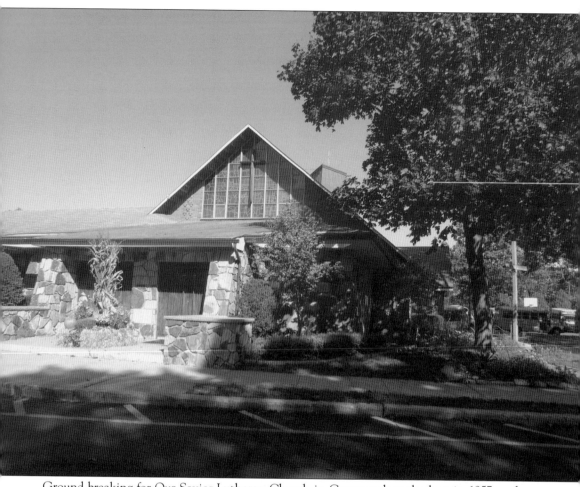

Ground breaking for Our Savior Lutheran Church in Centereach took place in 1957, and on February 23, 1958, it became an official congregation, with 126 charter members. Originally, a small group began worshipping in a cottage on Unity Drive in 1956, but on November 24, 1957, the group moved into the newly built church, which was dedicated on January 19, 1958, by its pastor, Rev. Kenneth E. Hoener. The one-story building was constructed of brick and redwood and designed to contain a sanctuary with a seating capacity of 250, Sunday school rooms, a pastor's study, washrooms, and storage space. On the church's 10th anniversary in 1968, seventy-three members out of the original one hundred twenty-six were still members of the congregation. Today, the church boasts a membership of approximately 200 families. Our Savior New American School opened in 1992 with an enrollment of nine students. Currently, there are an estimated 225 students in the school, ranging from kindergarten to 12th grade.

Believed to have been an old Norton family cemetery, Union Cemetery, located on Middle Country Road, northwest of the Selden Fire Department, has been enlarged in recent years. Included in those interred here are members of the Norton, Still, Dare, and Mitchell families of Selden.

Located adjacent to the historical New Village Church on Middle Country Road is the New Village Congregational Church Cemetery. The first interment in this quiet churchyard in 1819, one year after the church was built, was that of Deacon Isaac Gould's sister, Sarah A. Gould, who was born on May 30, 1814, and died on April 4, 1819.

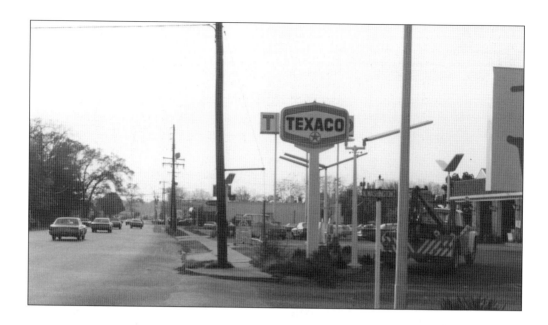

While the image above, a 1975 view of the northwest corner of Middle Country Road and Washington Avenue in Centereach, shows a developing retail environment, trees still line the south side of the road, evoking a sense of a quiet community. It can be assumed that the single Texaco gas station on the road did not have to advertise its prices because it lacked local competition. The photograph below, taken in 1987, shows Middle Country Road near Marshall Drive in Selden in the midst of a panorama of retailers' signs competing for customer's attention and sales, while the greatly increased traffic causes congestion.

In 1969, on land which once housed barns and farm implements, a shopping center bearing the name Smith Haven Mall brought a new and different lifestyle to the surrounding communities. It now includes 1,400,000 square feet of retail space. Of the four original anchor stores—Macy's, Abraham & Strauss, Sears, and Martin's—only Sears and Macy's remain. Gone, too, are old-time favorites such as Sam Goody Music Store, Kay-Bee Toys and Hobbies, McCrory's, Orange Julius, Time-Out Amusements, Waldenbooks, and Wallach's. In 2006–2007, the mall underwent a major multimillion-dollar renovation project in which a lifestyle village was built, replacing the space occupied by Stern's and adjacent parking lots. Since 1995, Smith Haven Mall has been managed by the Simon Property Group, which owns 25 percent of the mall and is one of the largest developers of shopping malls in the United States.

In 1959, the first McDonald's opened in Centereach at the corner of Middle Country Road and Hammond Road. It became a very popular spot for local families and was a well-known part of the community. During the week of its first anniversary, McDonald's offered a free All-American lunch to those who could provide proof of their birthday. Many advertisements from that time have the familiar McDonald's slogan "Look for the Golden Arches." By 1964, the Centereach McDonald's had sold four million hamburgers and one million pounds of potatoes in french fries. To give an idea of what McDonald's charged in those days, a hamburger cost 15¢ and its All-American meal consisting of a hamburger, shake, and french fries cost only 47¢. A family of five could eat for $2.35. Pictured here are local student Richard Neidhart (right) and an unidentified colleague.

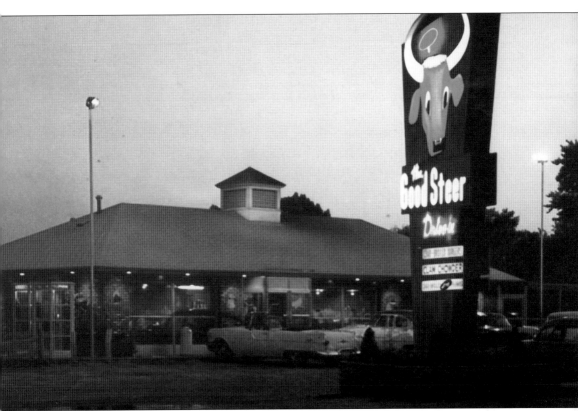

Since 1957, the Good Steer restaurant in Lake Grove, known for its famous onion rings requiring 3,000 pounds of Spanish onions weekly, has been operated by the McCarroll family. Located near the corner of Hawkins Avenue and Middle Country Road, the Good Steer began as an upscale hamburger stand with roll-down garage doors. With seating capacity for 240 diners, it became a favorite destination for celebrities, including E.G. Marshall, Farley Granger, Bert Lahr, Ava Gardner, and the Gabor sisters. In 1965, the Good Steer underwent a major refurbishing, with the restaurant enlarged and the kitchen and dining area modernized. The restaurant begun by Robert and Elizabeth McCarroll is still owned and operated by the family to this day and continues to be a destination for Long Islanders. (Courtesy of the Good Steer.)

In 1960, the Suffolk County Board of Supervisors approved the establishment of the county's first community college on the former Suffolk Sanatorium site. Although Suffolk County Community College held its initial year of classes at Sachem Junior-Senior High School in Ronkonkoma, the Suffolk County Community College began using the old sanatorium facilities permanently in September 1961. The building above, which served as the sanatorium infirmary, was constructed in 1918. Later on, it became the faculty offices when the site became Suffolk Community College. Pictured below is the original full-time faculty at the college. From left to right are Louise F. Van Wart, J. Rankin, Frank E. Martin, Dr. Harold R. Hartman, Dale B. Lake, Laura L. Hackett, Eugene J. Sullivan, and Dr. A. Michael De Luca. (Both, courtesy of Ray Welch.)

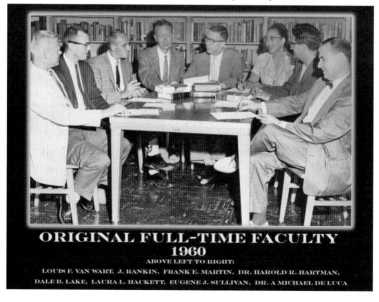

ORIGINAL FULL-TIME FACULTY
1960
ABOVE LEFT TO RIGHT:
LOUIS F. VAN WART, J. RANKIN, FRANK E. MARTIN, DR. HAROLD R. HARTMAN,
DALE B. LAKE, LAURA L. HACKETT, EUGENE J. SULLIVAN, DR. A MICHAEL DE LUCA

This photograph shows Babylon town supervisor Gilbert C. Hanse (left) and president of Suffolk County Community College Albert Ammerman at the ground breaking for the Babylon Student Center around 1966. This was the third new building on the campus and the first one constructed on the Academic Quad, which is now called Veterans Plaza. (Courtesy of Ray Welch.)

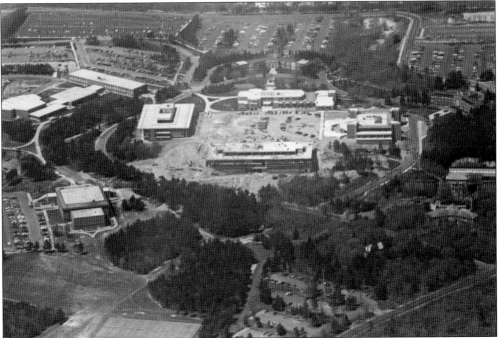

The Ammerman Campus of the Suffolk County Community College in Selden, shown here, opened in August 1961 on the grounds of the old Suffolk Sanatorium. Named after the college's founding president, Dr. Albert M. Ammerman, the college held its first commencement exercises in June 1962 with 42 graduates receiving associate degrees. Two more campuses were built later, in Brentwood and Riverhead, and today the college enrolls approximately 27,000 students and offers more than 100 degree and certificate programs. Overall, the college has had more than 104,000 graduates since its inception. (Courtesy of Ray Welch.)

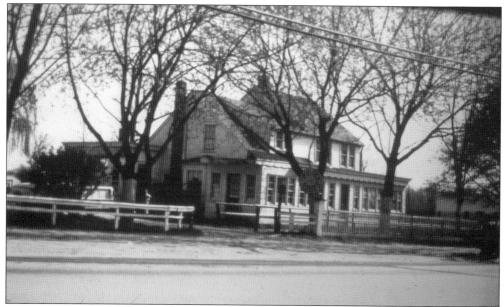

Originally, this 52-acre home and farm on Middle Country Road, east of Dietz Avenue, belonged to Alfred and Ellecta Hawkins in the late 1800s and early 1900s. By 1940, Theodore and Emily Schwamb owned the farm, the last remaining one in the area to raise garden vegetables for sale at a stand. Emily Schwamb, confined to a wheelchair because of multiple sclerosis, put up a roadside wishing well at the farm stand and raised an average of $7 to $8 a day for multiple sclerosis research.

Fletcher's Hobby House, a well-remembered hobby emporium of the 1960s, was located in the former George Campbell home on the northwest corner of Wood Road and Middle Country Road. In the back of the storefront, one can see the second floor of the original George Campbell house. (Courtesy of Barbara Russell.)

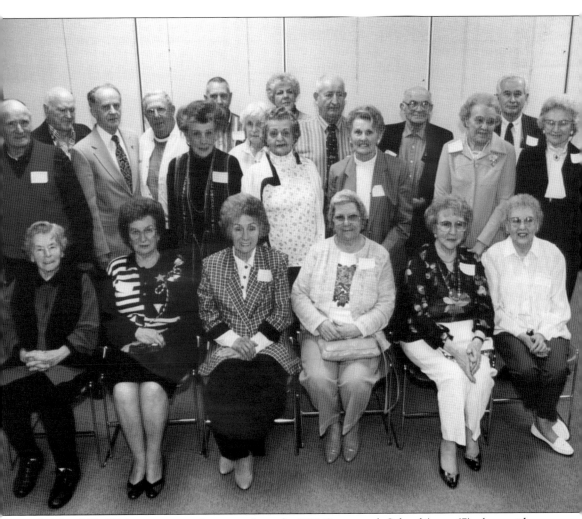

On April 18, 1994, twenty-one classmates from the 1931 Centereach School (page 67), along with their spouses, children, and some grandchildren, gathered at the Middle Country Public Library for a memorable reunion. Brookhaven town historian David Overton and schoolmates David Williams, Muriel Overton Williams, Shirley Benson Siegrist, and William Blydenburg recalled a time when farming was the local industry and the combined population of Centereach and Lake Grove was less than 1,500. Schoolmates reunited at the library; pictured, from left to right, are (first row) Minnie Moller Allgaier, Marjorie Zsembery, Frances Moller Gowen, Jennie Manitta Burckhardt, Florence Duffield Shaw, and Helen Norbeck Mickaliger; (second row) Carl Moller, Frances Davern Blydenburgh, Julia Martinek Burr, Muriel Overton Williams, Vera Smith Zabreski, and Shirley Benson Siegrist; (third row) Nelson Newton, David Overton, William Blydenburgh, Robert Urban, Melba Campbell Strom, Ruth Campbell Manitta, Alex Takats, Charles Ulrich, and David Williams.

The Lake Grove Village Hall was established to serve one of Long Island's oldest inland communities. Though most villages were settled along the shores of the island, Lake Grove was so situated due to its proximity to the old King's Highway, or Middle Country Road, as it is known today. The James Gould house, part of Lake Grove Village Hall, is listed on the F.W. Beers & Company map of 1873 as the property of J.B. Gould. By 1906, this property was known as Gould Farm and was owned by G. Gould, as recorded on the Hyde Atlas of that year. In the 1930s, the property was transferred from George to Harold Gould, who established Gould Feeds there. Later, during the 1940s, this home was the site of Lake Grove's post office, administered by postmaster Harold Gould, who lived there.

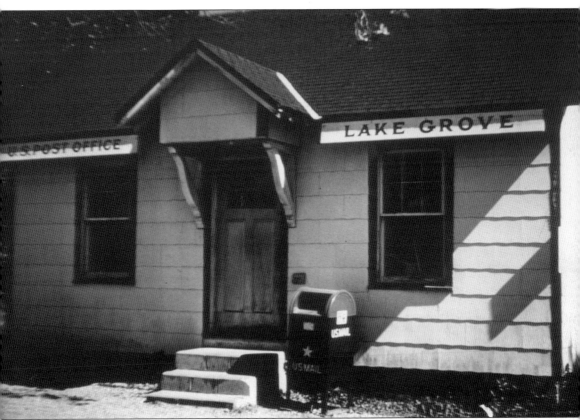

In 1870, Lake Grove established its first post office, which has changed location and postmasters several times throughout its history. The first postmaster, Abraham Roseman, carried the mail to and from the Lakeland Railroad Station by horse and wagon. Around 1890, Jacob DeBaum, followed by Laura Washburn, held the postmaster title. After this period, the post office was moved to Samuel Hawkins's general store, where Hawkins held the postmaster position until the office moved to the home of James Gould, with Harold Gould as postmaster. Frank Ness became postmaster in 1933 with a yearly salary of $1,060, which was dependent on stamp sales and could fluctuate from year to year. Ness saw the post office through another location change, moving from the southwest corner of Hawkins Avenue and Public Road to the east side of Hawkins Avenue. The post office was rebuilt in 1963, once again on the east side of Hawkins Avenue and approximately 50 feet north of Washburn Avenue, before being relocated to its present position, just south at 1001 Hawkins Avenue.

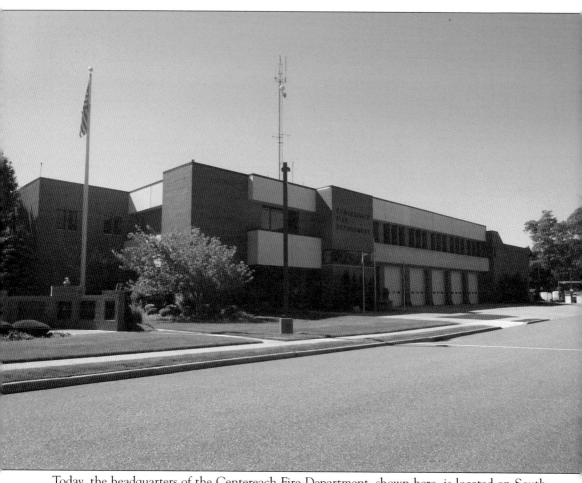

Today, the headquarters of the Centereach Fire Department, shown here, is located on South Washington Avenue in Centereach. Substations are also located on Stony Brook Road and North Howell Avenue. The North Howell Avenue substation was rebuilt in 2005. Construction on the headquarters building started in 1976 and it opened in 1978. The building is equipped with 12 bay doors, six in the front and six in the rear. Overall, the department has five engine trucks, one ladder truck, two rescue trucks, one brush unit, and four ambulances. Responding to 3,000 calls each year, the Centereach Fire Department received the EMS Agency of the Year Award in 2013. That same year, the department also celebrated its 80th anniversary. Today, the department that started in 1933 with just 46 volunteers has grown to 200 members among its three stations.

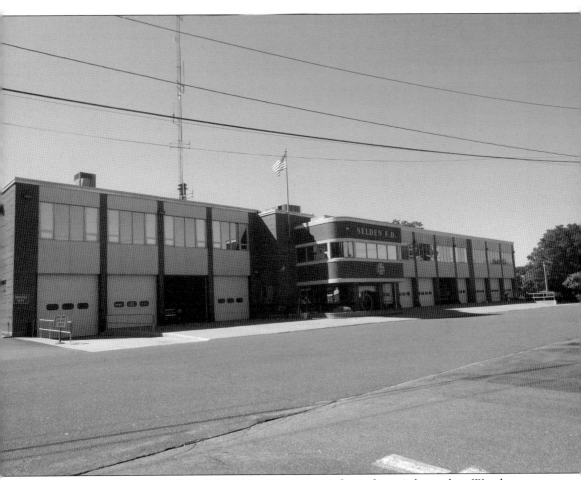

The current headquarters of the Selden Fire Department, shown here, is located on Woodmere Place in Selden. The left-hand portion of the headquarters building was constructed in 1964, the center in 1984, and the right in 2007. Headquarters boasts 12 bay doors for its two engine trucks, two rescue trucks, three ambulances, and one fire police vehicle. A substation is also located on Magnolia Drive. It holds two engine trucks, one rescue truck, one ambulance, and a fire police vehicle. The department has one paid paramedic and one volunteer paramedic vehicle. All calls are relayed from the central radio station located in headquarters, shown here in the top central portion of the headquarters building. The department is also in possession of three brush trucks, one of which is known as a storm and stump truck. These trucks are able to be driven on trails and through woods and high water to respond in the event of brush fires or weather emergencies. Currently, the department has 180 members.

In 2002, the Centereach Chamber of Commerce was revived through the efforts of key members of the local business community. It quickly became a valuable resource for businesses not just in Centereach but also those in Selden, Lake Grove, and beyond. In the spring of 2005, the board decided to update the name of the chamber to the Greater Middle Country Chamber of Commerce, to reflect its rapidly growing membership throughout the Middle Country area. Since then, the chamber has focused on its mission helping businesses prosper in Centereach, Selden, Lake Grove, and surrounding areas by supporting the business and civic interests of the chamber members and community residents.

The mission of the Brookhaven Department of Parks, Recreation and Sports, and Cultural Resources is to provide year-round amenities, services, and varied athletic and recreational opportunities to all residents. On May 26, 2011, a new building was dedicated on previously vacant land on Hawkins Road, which was given to the town by Levitt Builders. This eco-friendly building houses administrative offices as well as a recreational complex. A swimming pool, children's play zone, and tennis and basketball courts are a few of the recreational resources available to town residents. The town operates 170 various parks, sports complexes, playgrounds, ball fields, beaches, pools, recreation centers, marinas, and docks.

The TIMES

of Middle Country

Serving: Centereach · Selden · Lake Grove

Volume 1, No. 1 April 21, 2005 Postal Patron | 75¢

Budget adopted

Plan yields 8.94 percent tax rate increase

BY ELIZABETH W. SOBEL

Members of the Middle Country Board of Education and administrators were generally pleased with the school district's adopted budget. On April 6, the board voted unanimously to adopt a $165,278,170 spending plan for the 2005-06 school year for its 11,371 elementary and secondary school students. The adopted budget represents a spending increase of $10.7 million or 6.95 percent more than this year's budget totaling $154,540,276.

Superintendent of Schools Leonard Adler told residents that the board was able to reduce the preliminary expenditure plan by approximately $750,000 due to state aid. For the first time in 21 years, New York State lawmakers approved a state budget on time and offered Long Island school districts an extra $107.6 million, or $11 million more dollars than appropriated by the state for this year. Middle Country School District received $73,615,462 in estimated state aid, a 2.98 percent increase over last year. Adler said the increase eliminated the need for the district to cut programs.

> 'We've come a long way and have been relatively successful in tightening up.'
> — SUPERINTENDENT OF SCHOOLS LEONARD ADLER

"We've come a long way and have been relatively successful in tightening up," Adler said.

When voters go to the polls on May 17, they will be voting whether to approve a budget with an 8.94 percent tax rate increase which would translate to a tax rate of approximately $153.07 per $100 of assessed value. The budgeted school tax levy amounts to $84,652,900 or a 9.31 percent change over last year. Assistant Superintendent for Business Herb Chessler said the percentage change in the school tax levy is

Continued on page A6

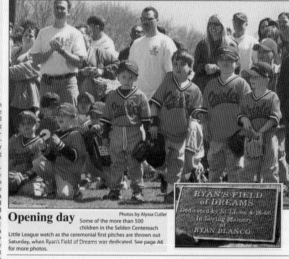

Opening day Some of the more than 500 children in the Selden Centereach Little League watch as the ceremonial first pitches are thrown out Saturday, when Ryan's Field of Dreams was dedicated. See page A6 for more photos.

Photos by Alyssa Cutler

RYAN'S FIELD of DREAMS
Dedicated by SCLL on 4-16-05
In Loving Memory
of
RYAN BLANCO

Time to clean up roads?

Residents raise concerns on roadside garbage

BY CAROLINE LINTON

Do the streets of Centereach and Selden need better maintenance?

Many residents say, yes, the streets are in need of more frequent garbage removal, but even more, stricter penalties are needed for those people who ignore the garbage removal laws.

"I was so excited when I saw a street cleaner go by," said Pat Wagor of Selden, who attended Councilwoman Geraldine Esposito's (R-Selden) community forum on March 25 to speak out about the problem.

The debate over garbage cleanup took center stage at the forum, where not only Wagor, but many other community members asked, "Why do our streets always look so dirty?"

Esposito welcomed their questions, but said the town "cannot keep up with the amount of garbage people put out on the road."

Esposito said that, in the past, county prisoners were used to pick up the garbage, but that practice was discontinued because many people did not like prisoners

Continued on page A4

Take a look at us

Since you are receiving The Times of Middle Country for the first time, please consider this issue an introduction and an invitation to explore what's inside.

Our staff of professionals works hard to bring you information that is relevant to your lives — from the latest news stories to our comprehensive calendar, our provocative letters page — and especially the accomplishments of our children, neighbors and friends in our hometowns.

We hope that when you are finished looking us over you will join our family of subscribers. To do so, just fill out the coupon printed on page A10.

Also, please feel encouraged to contact us with news tips, bragging rights about members of your family, your business, or your community groups, a letter to the editor or a heads-up on some community event. We will be delighted to hear from you, and our 29-year-old news organization is privileged to serve you.

And yes, you can call us up on the World Wide Web at www.timesofmiddlecountry.com. Enjoy the read!

Sincerely,
Leah S. Dunaief
Editor and Publisher

Living dangerously	Her eyes are on the prize	Asian Heritage Festival	Reflections of Middle Country	Our House in Spring
Narrow road, trees cause concern on Hammond	Selden girl takes Empire bronze in luge	Library spotlights cultural diversity	Looking back in library's Heritage Collection	It takes a village to build a special house
Page A3	Page A3	Page A5	Page A7	Inside this week

For Late Breaking News! www.portjefferson.com

Throughout almost all of their history, the communities of Selden, Centereach, and northern Lake Grove have never had their own newspaper. All of that changed in the wee hours of the morning of April 21, 2005, when the first issue of the *Times of Middle Country* rolled off the presses. A weekly newspaper, a Times Beacon Record publication, edited and published by Setauket resident Leah Dunaief, informs the three communities of local news and events. With this community paper, news of local education issues, high school sports teams, local civic leaders, editorials, and letters to the editors on neighborhood concerns are preserved in print. As the paper's first page promised it would, it has brought "the accomplishments of our children, neighbors and friends in our hometown" and remains "our community newspaper with its eye on the world."

On May 24, 1957, Lucille Hough, first chairman of the library board of trustees, officiated at the library's ribbon cutting as it was officially organized to serve the hamlets of Centereach and Selden. The former Nature's Gardens Community Clubhouse was donated by developer O.L. Schwenke to be used as its official site. In 1986, the building was closed and the Middle Country Public Library in Selden was opened in the renovated Selden School (above). After the library was chartered as the Selden-Centereach Public Library in 1960, a drive to stock the shelves at a rented site at 8 Dawn Drive (below) in Centereach was spearheaded by library officials with the support of Tinker Bank and the builders of Dawn Estates, Bernard and Theodore Kaplan. With demand for library services growing, a vote for building in Centereach was approved by the community in 1969, and ground-breaking ceremonies at 101 Eastwood Boulevard took place in 1970.

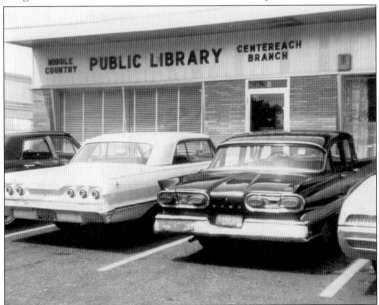

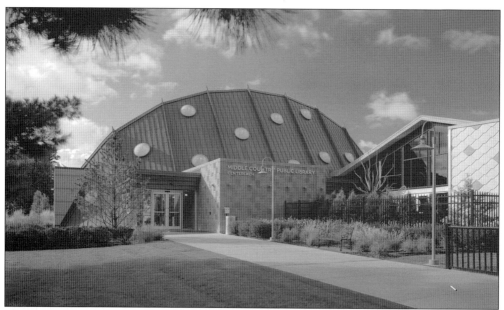

During more recent years, the library buildings were not able to support the level of service and programs provided or adequately satisfy the explosion of new residents migrating to the area. Recognizing the need for additional space, residents overwhelmingly supported the passage of bond issues in the late 1980s and again in the late 1990s. The total expansions of facility space by 40 percent enabled Middle Country Public Library to maintain and nurture its position as a pioneer in library services. The state-of-the-art facilities shown above and below boast a combined total of 107,000 square feet and include the Miller Business Resource Center, the Museum Corner, the Nature Explorium, the Underground, the Reading Garden, the Family Place, and the Family Place Training Center.

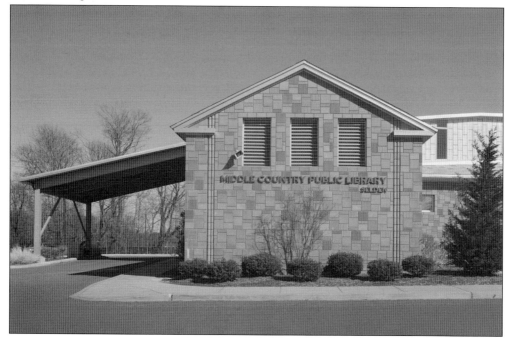

BIBLIOGRAPHY

Beers, Frederick W. *Atlas of Long Island, New York: From Recent and Actual Surveys and Records under the Superintendence of F.W. Beers.* New York: Beers, Comstock & Cline, 1873.

Boutcher, Sharon. "The Hallock Family Farm of Lake Grove, Long Island (18th Century–1962)." Unpublished manuscript, April 16, 1981.

Burr, David H. *An Atlas of New York: Containing a Map of the State of Documents Deposited in the Public Offices of the State and Other Original and Authentic Information under the Superintendence and Direction of Simeon de Witt, Surveyor General, Pursuant to an Act of the Legislature; and Also the Physical Geography of the State and of the Several Counties and Statistical Tables of the Same.* New York: D.H. Burr, 1829.

Chace, J. *Map of Suffolk Co., L.I., N.Y: From Actual Surveys.* Philadelphia: John Douglass, 1858.

Dolph and Stewart. *Part of Brookhaven. Map of Farmingville, Medford, Lake Grove, Centereach, Selden, New Village, New York.* New York: Dolph and Stewart, 1929.

Furman, Charles Elmer. *Year Book and Church Directory of the First Congregational Church of New Village, Middle Country Road, Centereach, N.Y.* Lake Grove, NY: First Congregational Church, 1933.

Grendler, Caroline Howell. "James Howell, 1771–1848, of New Village, now Lake Grove, Suffolk County, New York and Some of his Descendants." Unpublished manuscript, 1959.

Hallock, Lucius H. *A Hallock Genealogy; An Attempt to Tabulate and Set in Order the Numerous Descendants of Peter Hallock, Who Landed at Southold, Long Island, N.Y., about the Year 1640, and Settled at Aquebogue near Mattituck.* Riverhead, NY: Harry Lee Publishing, 1928.

Hyde, Merritt B. *Atlas of a Part of Suffolk County, Long Island, New York; North Side—Sound Shore, Complete in Two Volumes.* New York: E. Belcher Hyde, 1909.

Long Island Rail Road Co. *Cyclists' Paradise: A Guide for Cyclists with an Accurate Map Showing the Roads and Cycle Paths of Long Island: With Notes, Suggestions, Runs, Hotels and Time Tables Sufficient to Enable Any One to "Lay out a Trip" Intelligently.* Long Island City, NY: Press of Charles Day, 1899.

Roe, Daniel. *The Diary of Captain Daniel Roe, an Officer of the French and Indian War and of the Revolution. Brookhaven, Long Island, during Portions of 1806-7-8.* Annotated by Alfred Seelye Roe. Worcester, MA: Blanchard Press, 1904.

Smith, Alvin R.L. *The Overton Genealogy; The Overton family of Long Island, New York, Especially the Descendants of David Overton of Southold and Coram, 1640–1965* Centereach, NY: 1965.

Weiss, Luise. *The Hamlet of Selden: An Historic Chronicle.* Centereach, NY: Adult Services Dept., Middle Country Public Library, 1986.

Weiss, Luise and Doris Halowitch. *The Chronicle of Centereach.* Centereach, NY: Middle Country Public Library, 1989.